The
PHOTOGUIDE
to
Filters

THE ⓟ PHOTOGUIDES

The
PHOTOGUIDE
to
Filters

Clyde Reynolds

Focal Press
London & New York

ISBN 0 240 50923 4

Text set in 10/11 pt. Photon Univers, printed by photolithography and bound in Great Britain at The Pitman Press, Bath

Contents

Acknowledgements
Thanks are due to a number of people and companies; but special mention should be made of BDB, Hoya and Kodak Ltd for supplying most of the pictures, taken through their filters.

10

What
are
Filters

Any discussion of photography sooner or later turns to filters. There seem to be so many filters, for so many purposes, that all is confusion to the beginner. In fact, all filters act by restricting the light or other radiation reaching the film, and the multiplicity of effects is the product of the interaction of the remaining radiation with the emulsion of the film. Once you can understand what a filter is doing, you can predict its effect on any type of film.

The nature of filters

Filters are made from a clear support substance which is dyed or coated to absorb some of the radiation which falls on it. The effect is usually visible as a change in the colour of light transmitted. In the simplest terms, for example, a red filter absorbs all the other light, thus letting through only red. In practice most filters used in photography let through some light of all colours, and may be thought of as reducing light of a complementary colour (see p 29). Each filter is made to absorb a carefully calculated range of radiation, giving it a characteristic colour and effect.

Some filters restrict only invisible radiation. The commonly-used ultra-violet (UV) filter is more or less opaque to ultra-violet radiation, while being perfectly transparent to visible light. As most films are somewhat sensitive to ultra-violet rays, the visually clear filter can affect the photographic reproduction of a scene. A similar visually transparent filter which absorbs infra-red radiation is produced for use in making colour prints.

Other filters are totally visually opaque, but allow specified invisible radiations to pass through. The most widely used filter of this type transmits infra-red radiation. Such a filter can be used to take photographs in the dark without a light to betray the photographer.

Sometimes it is necessary to reduce the intensity of radiation without altering its composition. Neutral density filters (attenuators) serve this purpose. They are made in two basic types, one of which has a grainy structure and forms a diffused image if used on a camera or enlarger lens. The other type is made like other filters, and can be used to reduce camera or enlarger exposure levels independently of any aperture changes.

Polarizing filters (screens) are another type of neutral filter. They restrict the passage of light to that polarized in one particular plane. With diffused lighting, they act like a neutral density filter. However,

with hard lighting polarizing filters can act differentially on specular reflections; with carefully controlled polarized sources they can eliminate reflections entirely. Because light reflected from some parts of a blue sky is polarized, polarizing filters can be used to alter the sky tone or colour selectively without affecting the rendering of other colours in the photograph.

Photographic filters are designed to be used with films sensitive to light and to radiation just outside the visual range. It you want to use radiation (either infra-red or ultra-violet) far beyond the visible spectrum you must take account of the absorption qualities of the filter base and of your camera lenses. The necessary data can be found in filter manufacturers' literature or by experiment. For all normal photographic purposes, however, filters can be presumed transparent except to the radiation they are intended to absorb.

For use on a camera or enlarger lens, filters must be optically perfect if they are not to distort the image. They are usually made exactly the right size, and mounted in a holder suitable for attachment to the front of the lens. Filters may also be used on light sources – as they are in stage lighting. In that case, they need not be made to any great accuracy (although they must be the correct colour) and are often supplied in large sheets or rolls.

Apart from filters, various other before-the-lens attachments are used in photography. Additional lenses alter the focal length of the camera lens – or part of it – to allow much closer-than-normal focusing. Part lenses allow some of the foreground and some of the background to be rendered sharp simultaneously. Multiple prisms can produce a series of partly-superimposed images of a subject, the pattern determined by the prismatic construction. Diffraction gratings or etched discs can produce star-like effects on subject highlights; and various degrees of diffusion or softness can be produced with roughened or smeared screens.

Exposure

Because they reduce the light reaching the film, most filters make a longer shutter speed or a wider lens aperture necessary. The amount by which the time or aperture must be increased over that needed without the filter is called the *filter factor.* Thus, for example, a filter factor of 2 (\times2) implies that the shutter must remain open for twice as long, or the aperture must be twice as wide (one stop more). Thus instead of $^1/_{125}$ at *f*8, you would give $^1/_{60}$ at *f*8 *or* $^1/_{125}$ at *f*5.6.

13

Throughout this book, exposure recommendations are given in stops. Where parts of a stop are indicated, they are given at one-third intervals. This allows you to alter your film speed setting by a suitable number of DIN or ASA steps. If you use the recommendations to alter your aperture setting directly, either $\frac{1}{3}$ or $\frac{2}{3}$ can be regarded as half a stop. Through-the-lens meters can read through the filter, but may respond unusually because the light is an unusual colour. To get exactly the effect that the manufacturers intend, you should meter without the filter, and use the manufacturer's exposure factor to modify the result.

Detailed exposure information is given in pages 171–175.

How filters affect colour films

Colour films record all the colours of the subject so that they can be represented correctly. With reversal films, the coloured images are produced in the film that is exposed in the camera, whereas with negative films, they are produced on colour paper during printing from a negative.

The colours of a transparency are a more-or-less accurate representation of the colours reaching a reversal film. If you put a coloured filter on the camera, it alters the colour of light reaching the film, and thus the colour of the processed transparency. You can do this either for special effects or to take account of the lighting. Most reversal colour films are made to be used with one sort of lighting only: either daylight, a rather bluish colour; or one of the more yellow-coloured artificial sources. If you use a film in a different type of lighting, it gives unusually coloured transparencies unless you filter either the light or the camera lens.

The exact colour of a print from a negative is determined by using filters at the printing stage. Thus it is not normally necessary to use coloured filters on the camera. However, printing from certain professional type films is much easier if (like a transparency film) they are used with a light-source filter.

Ultra-violet absorbing filters reduce the blue colour and haze sometimes found on colour transparencies. Although the colour can be removed during printing from a colour negative, any haze will remain. So a UV filter is often helpful even with colour negative films. The selective effect of a polarizing filter applies equally to reversal or negative films.

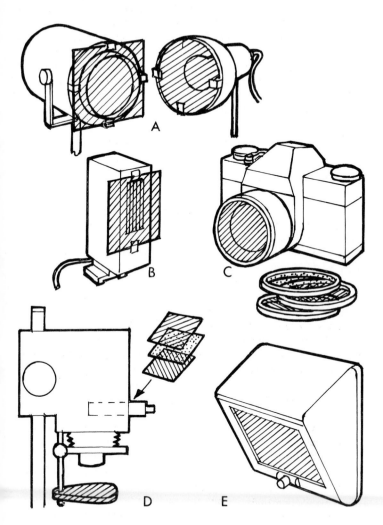

Coloured filter materials may be used in many places to influence photographs. A, On studio lights. B, On a flashgun. C, Special optical quality on the camera lens. D, They are used in colour printing. E, Safelight filters let you see without fogging your materials.

How filters affect black and white films

Modern black-and-white film produces a picture in a series of grey tones approximately matching the tones of a coloured subject. Using a coloured filter on the camera lens alters the relative tones of different coloured parts. Basically, if you use a colour filter and make the necessary exposure compensation you lighten parts of the subject the same colour as the filter, and darken parts of a complementary colour. For example, if you take a picture through a yellow filter, not all the blue (which is the complement of yellow) light reflected by the subject reaches the film. So blue areas reproduce darker in the final print. In fact, because most parts of the subject reflect some blue light, the whole picture is darkened, and you have to increase the exposure if you want a negative the same overall density as that produced without the filter. At the same time, the increased exposure lightens all the non-blue reflecting parts, that is, the yellow ones.

Haze tends to be mainly blue-reflecting, so one use of a yellow – or even red – filter is to reduce haze to an even greater extent than is possible with an UV absorbing filter. A polarizing filter has a selective effect as it has with colour films.

Filtering the light source

When you use a controllable light-source, you may want to filter that, rather than the camera lens. The effect on the film is virtually identical whether the filter is fitted over the lights or the lens. Naturally, you need more and usually larger filters for light-sources – especially if you have to cover a whole window. You do not, however, need high quality materials nor to take such great care of them.

A special case occurs if you use mixed light sources of different colours for colour photography. Unless you want the different colours to show, you have to use filters to ensure that all the light is the same colour. You may then have further to filter the camera so that the light is suitable for the film you are using.

Why use filters?

As filters alter the light reaching a film, and so the photograph, they can be used to correct deficiencies in the picture. You can use a filter

to make a black-and-white image more nearly match a visual impression of a scene; or a coloured picture come out with white 'whites' and natural-looking skin tones. You can use a polarizing filter to reduce reflections or darken a sky; or a UV-absorbing filter to cut haze. These are all ways to 'improve' a normal picture, but filters may also be used to create novel effects. You can use strong red filters to create stark moonlit scenes on black-and-white films; or any strong colours – either on your lights or camera – to make brilliantly coloured transparencies. If you combine filters with special effects screens and other creative camera techniques, the range of possibilities is immense.

This book is intended to help you understand filters, and to give you the information you need to be able to get just the image you want on your film.

The Nature
of
Light

'Photography' means writing with light. It uses light — and closely related radiation — to record shapes, tones and colours. Filters can modify the light (and other radiation) that reaches the sensitive film. To understand the way in which filters can be used in photography you need a basic knowledge of the nature of light, and the way a photograph is made.

Light is that part of the whole range of electromagnetic radiation (which stretches from radio waves to cosmic rays) that we can see. It travels in straight lines unless it is reflected, refracted or absorbed by matter. Reflection takes place at opaque surfaces; it may scatter the light, or it may be hard 'specular' reflection as from a mirror. Light is refracted (bent) as it passes from one transparent medium to another (such as from air to glass or vice versa), and thus can be brought to a focus by a lens. This happens in our eyes, and the light-sensitive retina on which the image forms then transmits a picture of the scene to our brain.

A similar process occurs in a camera, where the image is formed on light-sensitive film. When processed, the film shows a picture of the image that was focused on it. To make things more complicated, photographic emulsions can be sensitive to a greater range of radiation than our eyes. However, when films are used in a camera under normal circumstances, most of the radiation that can get through the lens is light; thus the picture produced closely resembles what we saw when it was taken. There are, however, many exceptions; for example, radiography depends on sensitivity to an invisible form of radiation (X-ray or gamma rays), as do infra-red and ultra-violet photography.

All radiation has a vibratory or wave motion. The distance from one trough or peak to the next is called its *wavelength*. The wavelength determines what sort of radiation it is (see p. 218).

The visible spectrum

Human eyes are sensitive not only to the presence of light, but to its wavelength. We see different wavelengths as different colours. In fact, humans can distinguish over 200 different hues formed from single wavelengths or simple mixtures of wavelengths. When all the visible wavelengths are mixed together, roughly equally, we see white. When no light is present, we see black.

Sunlight, which contains about equal parts of all visible wavelengths,

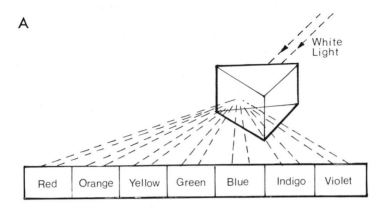

A

White Light

| Red | Orange | Yellow | Green | Blue | Indigo | Violet |

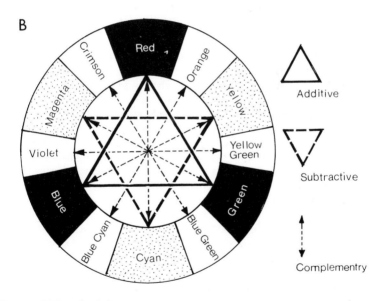

B

Additive

Subtractive

Complementry

The colours of the spectrum. A, White light can be split by a prism into its component colours. B, The colours can be arranged in a circle with each opposite its complement. Additive and subtractive primaries are then at the corners of two triangles.

is split up by raindrops to show the separate colours in a rainbow. The same effect can be demonstrated with a simple glass prism. This refracts (bends) light rays through an angle determined by their wavelength. Although the spectrum so demonstrated is continuous, the eye sees it as a set of distinct colour bands. They can be simply described as: violet, indigo, blue, green, yellow, orange and red, in order of increasing wavelength.

The wavelength of light and closely related radiations is measured in nanometres (nm), which are one-millionth of a millimetre. So, we are talking of absolutely minute distances.

The visible spectrum stretches from about 400 nm – violet – to about 700 nm – deep red. This is the range we normally want to picture in a photograph. All coloured filters affect the transmission of light in this spectrum.

UV and IR radiation

Radiation with wavelengths just shorter than violet is called ultra-violet (UV). Below this come X-rays, gamma rays and cosmic rays. Because it is absorbed by photographic lenses, short wave UV can be disregarded for normal photographic purposes. So UV photography usually means photography with wavelengths between 400 nm (violet) and about 330 nm.

Wavelengths just longer than red are called infra-red (IR). They include the radiations we can feel as heat. Longer than IR are microwaves and radio waves. Photographic emulsions have to be specially sensitized to extend their range into the IR. Most IR photography is confined to wavelengths slightly longer than red. 'Normal' IR films reach about 880 nm, and extreme IR films to about 1150 nm. Like all other emulsions, they are still senstive to blue light and UV radiation. Unless you are using a purely IR radiation source, the camera lens must be filtered if you want to confine your exposure to the infra-red.

Coloured light

Light is coloured because of the relative proportions of different wavelengths. A strong red light contains a preponderance of long-wave radiation; and if split up by a prism, will give very little light out-

A

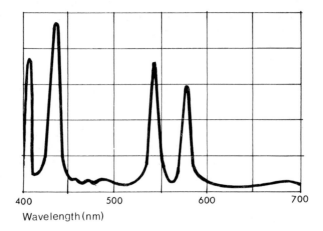

Wavelength (nm)

B

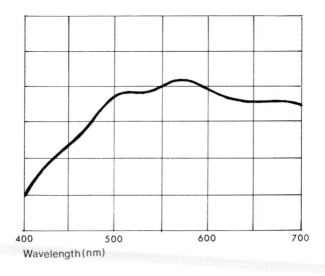

Wavelength (nm)

Distribution of light through the spectrum. A, Some sources, such as mercury vapour lamps produce an uneven, discontinuous spectral distribution. B, Others, such as sunlight have a more or less continuous spectrum.

side the red end of the spectrum. More pastel shades show a less uneven distribution. For example, a pink light may be evenly distributed throughout the spectrum, except for an excess of red.

Discontinuous spectra

Some light-sources are completely devoid of light of some wavelengths. They produce spectra with a series of separate bands — called discontinuous spectra. Most of the brilliant coloured emission lights characteristic of certain chemical elements have discontinuous spectra. The most widely seen of these is sodium light — commonly used for street illumination. Sodium light needs comparatively little filtering to produce a light-source composed entirely of one single wavelength (monochromatic). Fluorescent tubes also have discontinuous spectra. The exact mix depends on the purpose for which they are designed.

Photographic emulsions are intended to be used with continuous spectra; discontinuous light sources may produce unexpected results which cannot be predictably modified by filters.

Colour mixing

Human eyes distinguish light of different wavelengths as colour, but they also see mixtures of wavelengths as pure colours. Thus a yellow sensation may be caused equally by yellow light (570 nm) or by a suitable mixture of green (520 nm) and red (670 nm) light. Similarly, a suitable mixture of red (670 nm) and blue (470 nm) cannot be distinguished from violet (400 nm) light. In fact all the colours of the spectrum can be simulated exactly by mixing two out of three suitable primary colours.

The actual colours chosen depend on whether the mixing is to be done additively or subtractively. For *additive mixing,* imagine three separate white lights, one of which is fitted with each of the three primary colour filters. If all three are shone with equal intensity (and the filters are a perfect set of primaries) they will mix to form white light. All other hues (apart from the primaries themselves) can be made by mixing two of the three in suitable proportions. Colours made using all three lights (at different intensities) are always diluted with some white; i.e. they are somewhat pastel.

A — Red Light

B — Green Light

C — Blue Light

D — Pink Light

E — Pale Green Light

F — Pale Blue Light

400 500 600 700

Coloured light. Light is coloured because it has an unequal distribution of wavelengths. A B C, The spectra of strong colours are almost confined to parts of the range. D E F, Weaker colours have some light of all colours, but more of part of the spectrum.

Subtractive mixing occurs when filters are placed together on one light source. All three (perfect) subtractive primaries will stop all light from passing (i.e. they will give black). The spectral colours are simulated by mixing any two of the primaries in front of the lamp. The relative densities (strengths) of the two filters decide exactly what colour it will be. Thus, for subtractive colour control you need a range of filter strengths in each primary colour. Colour mixes including all three primaries always contain some neutral density, i.e. they are somewhat degraded by black.

The effect of *any* filter in a light beam is subtractive: i.e. it removes something from the light. To make things particularly confusing, additive mixing is normally achieved by adding together three colours of light each of which is coloured by the subtractive effect of a filter.

Primary colours

The additive primaries (or light primaries) are red, green, and blue (a rather violet-tinged blue). Light of these colours can be added together to form any other colour. The three intermediate mixes are yellow (red + green), magenta (red + blue) and cyan (green + blue). These are in fact the subtractive primaries (or secondaries) and are complementary to the primary colour missing in their mix. Colours at other points on the spectrum are made by mixing the primaries in unequal proportions: thus, red and half as much green gives orange; red and twice as much blue gives purple, and so on. Pastel shades are made by mixing all three in the required proportions, and degraded colours (colours including some black) represented by reduced intensities. For example, chestnut brown contains red and green in the same proportions as orange, but in lesser quantity. Our eyes can tell whether we see brown or orange by comparing the light intensity with black or white surroundings. When there are no suitable comparisons we cannot tell what tone we are seeing, and thus may see brown as orange, or vice versa.

For most purposes, we can treat light as if it were composed entirely of the additive primary colours (see page 28). Each of the additive primary filters by itself absorbs light of the other two colours completely. For example, a red filter absorbs all blue and green light. Two or more additive primary filters used together (i.e. subtractively) will theoretically absorb all light. This is because each transmits only light

of one colour, and absorbs the other two colours. Thus a red filter absorbs the blue and green, and either a blue filter and green filter absorbs red light.

Additive primary filters are used in theatre lighting systems when absolute flexibility of colour is required. As they absorb so much light, however, paler substitutes are used for most purposes; often supplemented by white light.

In photography, the most common use of additive colours is in colour printing. Light from these filtered sources can be mixed in an enlarger colour head to produce exactly the right colour. Alternatively, the print can be given three successive exposures through three primary filters (see page 187).

The subtractive primaries (or light secondaries) are cyan, magenta, and yellow, the complementaries of red, green and blue. When used together in varying densities over a single light source, filters of these colours can simulate any spectral colour. When they are put together in equal strengths, they produce the additive primary colours: cyan and magenta give blue; cyan and yellow, green; magenta and yellow, red. Subtracting some of all three colours from a light naturally reduces its intensity as well as changing its colour.

Subtractive primary filters transmit two colours of light each; thus a magenta filter may be considered a minus green filter, because it withholds green light and lets through red and blue. In the same way, a yellow filter (minus blue) transmits red and green light; and a cyan filter (minus red), blue and green light. This is reflected in the fact that 'pure' subtractive primary filters are much lighter than the additive primary (red, green and blue) filters. To avoid confusion, we will refer to the subtractive colours as secondaries, reflecting the fact that they are composed of two light primaries.

When used additively, the secondary colours produce comparatively pastel shades. Thus a magenta light added to a yellow light of equal strength gives one unit each of blue (from the magenta source) and green (from the yellow) and twice as much red (one from each). Thus the effect is the same as adding red light to white light (made up of equal parts of blue, green and red); i.e. a pale red colour, or pink light.

Secondary colours (or acceptable substitutes) are used in mechanical printing. The image is formed from minute transparent dots of cyan, magenta and yellow inks. The artist's primaries of blue, red and yellow are used for subtractive colour mixing, and are quite clearly related to cyan, magneta and yellow; the individual pigments are normally chosen to suit the colours to be mixed from them.

Three-coloured light

Red, green and blue light in the right proportion can produce light of any colour. This is not an integral property of light, but a result of the way our eyes distinguish colour. The colour-sensing mechanism appears to consist of three types of receptor (visual cones), sensitive broadly to red, green and blue light respectively. However, assuming all light to be made up from the three (additive) primary colours simplifies an understanding of filters.

The colour of light reaching our eyes or cameras depends on the colour of its original source, and on the colour of any objects from which it has been reflected (or through which it has been transmitted). Both solid and translucent objects colour light because they absorb part of it. For example, a red flower absorbs most of the blue and green from sunlight falling on it, and reflects mainly red light for us to see. Likewise, a red filter absorbs blue and green light and transmits only red. Thus, we can think of our light-source (whether it is the sun, an electronic tube or a tungsten lamp) supplying a mixture of red, green and blue light; and the objects around us (including filters) selectively absorbing all or part of the colours.

Remember the primary filters (red, green and blue) absorb two other colours each, and the secondaries (cyan, magenta and yellow) one each. Mixtures of primaries and secondaries absorb red, green and blue light in proportion to the mixture. Any filter which absorbs some of all three primary colours is *degraded* by the addition of black. Any filter which transmits some of all three is *diluted* with the addition of white. The degradation and dilution concept can equally be applied to the colour of light, or the colours of objects (which are coloured because they absorb light selectively).

When estimating the effect of a filter on light from a coloured subject, you should estimate the approximate 'composition' of the light; then you should estimate the approximate absorbtion of the filter. By combining the two, you can predict the composition of the light reaching the film. For example, the light from a blue sky contains blue light, but is also contains red and green light (otherwise it would be a strong primary blue colour). A deep yellow filter absorbs blue light, but transmits red and green. Thus, if you use such a filter for taking blue-sky pictures, the film will be exposed mainly to the red and green components. So the sky will be darker in the picture, but cannot come out absolutely black – assuming your exposure is long enough to record the rest of your subject.

Colour representation systems

Primary colours absorb two colours of light, and their complements (the secondaries) transmit the same two. Thus, if a pair of complementary colours are added together in front of a light, they absorb all the light. If, however, the pair are used additively on two light sources, the result is white; one colour being provided from the primary, and two by the secondary.

The primary and secondary colours may be set round a circle so that each is exactly opposite its complement. The primary colours are set at the points of an equal-sided triangle. This is a colour circle, which is usually drawn in segments, representing the primaries, and secondaries; and perhaps a set of intermediates. In a truly representative circle, each colour grades imperceptibly into the next to form a continuous curved spectrum. In fact, there is a colour (magenta) which is not represented in the natural spectrum. This bridges the gap between the red and violet ends.

Remembering a colour circle is an easy way of remembering which colours complement each other, and thus of knowing what effect filters will have. You will find a simple colour circle on page 67. Printing inks can't match accurately the colour of filters, so try to look at some primary and secondary filters and see exactly what colours are represented. Note how each colour is intermediate between those either side. Mixing the two colours either side (subtractively) produces the one in the middle.

More precise colour systems are discussed in the chapter on interpreting scientific data.

Light
Sources

We have so far assumed that unfiltered light is white. However, the composition of what we see as 'white' light is determined by its source, and by any filtration introduced in its path. The light we accept as white can vary in colour from a distinct blue to a strong orange. You can verify this by looking out from a tungsten lighted room as dusk approaches, or looking into a lighted window from outside on a dull day. Our eyes soon get used to the lighting we are in, and see white objects as white.

Colour films, on the other hand, cannot normally compensate for changes in light source (although type G movie film is intended to give acceptable pictures in a range of light sources). The colour of the lighting is reflected strongly in the colour of a transparency. The problem is alleviated with negative/positive systems, because the colour can be corrected at the printing stage to give the same neutral colour balance expected of a transparency exposed in suitable lighting.

Sunlight

Sunlight is a blue-white colour, containing a high proportion of short-wave light, whereas an ordinary incandescent light bulb is an orange-white colour with a high proportion of long-wave light. Sunlight reaching the surface of the earth is filtered by the atmosphere. As it passes through, part of the light is scattered by minute atmospheric particles. The scattering is far greater for short-wavelength light (violet and blue) than for longer wavelengths. Some of the scattered light reaches the earth as blue 'skylight'. The exact colour of the remaining sunlight depends on the distance it has travelled through the atmosphere. When the sun is high overhead, comparatively little filtering occurs, and the light is quite blue. On the other hand, when the sun is low on the horizon, the light travels obliquely through the atmosphere, and can take on an amber or red colour. Sometimes part of the atmosphere diffuses some red light as well; this gives the colour to a brilliant sunrise or sunset.

Daylight

For photographic purposes, we can consider daylight to be a mixture of sunlight and skylight. This is more or less the same colour whether

your subject is lit by a mixture of direct rays and blue skylight, or by light diffused through thin clouds. Most daylight type reversal colour films are manufactured to give acceptable colours in such circumstances. They give noticably blue pictures of subjects in the shade, lit only by skylight, and obviously orange-red pictures of subjects lit by low morning or evening sun. The correct choice of filters can eliminate these colours and give a 'normal' colour balance.

Tungsten light

Light from incandescent bulbs is an orange-white colour. The exact shade depends on the type of bulb. Domestic lamps are the most orange, and they become slightly less so at higher powers. Large theatre-type bulbs come next, then photographic studio lamps (such as Photopearl or Nitraphot) and tungsten halogen lamps. The least orange (most blue) tungsten lamps are the short-life over-run photofloods.

Colour transparency films are manufactured for use with either studio lamps or photolamps. A really neutral colour balance can be achieved only with exactly the right light source, or with an appropriate filter.

Flash light

Today, flash comes mainly from electronic tubes or blue coated bulbs. Both types provide a close approximation to daylight. Clear flash bulbs produce light somewhere between tungsten light and daylight. The exact colour is determined by the bulb filling (e.g. aluminium or zirconium).

Using the wrong light

The effect of exposing colour reversal films in lighting other than that for which they are intended is quite striking. Daylight type films used with tungsten light (whether over-run photolamps, studio lamps or domestic lamps) produce transparencies of a strong orange colour. Tungsten light films produce washed-out looking blue-green transparencies if exposed in daylight. These colour balance problems are overcome by using the correct filters. A strong blue filter gives

white 'whites' on daylight film with tungsten lighting, and an amber filter 'corrects' artificial light film for use in daylight. The most suitable filters depend on the sensitivity of the films and on the exact colour of the lighting. The process is so successful, however, that most Super-8 film is balanced for artificial light, and the cameras have an amber filter built in for use in daylight.

Colour temperature

Although we have discussed the colour of light sources in a general sense, we have so far made no attempt to quantify the colours. The definition of subtle colour differences has been the subject of a number of different approaches, but only two systems need concern us. The CIE system (see page 228) and the colour temperature system. Colour temperature is a way of describing the colour of evenly mixed light. That is: illumination covering the entire spectrum, but which is coloured because the various colours are present in different amounts. It is thus ideal for describing the colour quality of continuous light sources such as sunlight or tungsten light. It is not suited to describing coloured light, or light from sources with a discontinuous spectrum (see page 24) such as mercury vapour discharge lamps or fluorescent tubes. The colour temperature system is not uniformly effective (see page 227) but is a good guide in most cases. The colour is expressed in kelvins (K), on a scale that runs from about 1500 to 20 000 or more. Red or amber light sources have a low value. Yellow, white, and blue illumination is progressively higher up the scale. Suitable photographic light sources range from about 2800 to 7500K.

Quoted colour temperatures for common light sources are average figures and filters calculated from them give satisfactory colour transparencies for normal purposes. However, if a neutral colour balance is absolutely essential, you must remember that daylight varies from time to time and place to place, and that incandescent lamps vary with small voltage changes and with age.

If you must have an accurately neutral balance, or if you are using an unlisted light-source, you can measure the colour temperature with a colour temperature meter (see page 83). Such a meter could prove invaluable if you commonly take pictures under unusual conditions — whether they be morning and evening, or special artificial light. However, meters are not cheap, and for the occasional picture, a

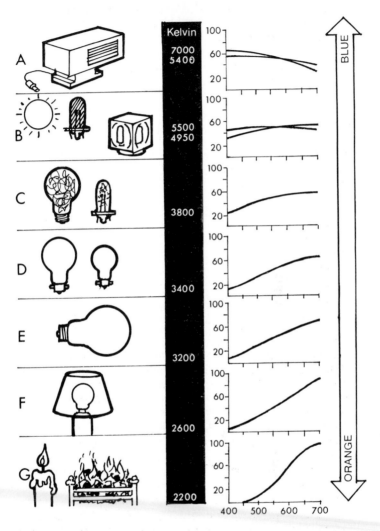

Colour temperature. The greater the proportion of blue in a spectrum, the higher its colour temperature; and the bluer its light. A, Electronic flash. B, Sunlight and blue flashbulbs. C, Clear flasbulbs. D, Photofloods. E, Tungsten studio lamps. F, Household lamps. G, Naked lights.

APPROXIMATE COLOUR TEMPERATURES OF SOME LIGHT SOURCES

Source	Colour Temperature	Mired Value
Skylight	12000–18000	85–56
Cloudy dull	6250	160
Electronic flash	5500–6500*	182–154
'Photographic' daylight (Daylight film balance)	5500	182
Blue-coated flash bulbs	5500	182
Mean noon sunlight	5400	185
Morning or evening daylight	5000	200
Flashcube or magicube	4950	202
Clear flashbulb	3800–4200	238–263
3400K Photolamps (Type A film balance)	3400	294
Tungsten studio lamps (Type B film balance)	3200	312
Tungsten halogen studio lamps	3200	312
Household lamps 250 watt	3000	333
Household lamps 100 watt	2900	345
Household lamps 40 watt	2650	377

*Most small modern units have a tinted discharge tube to bring them close to 5500K and sometimes lower.

series of exposures through likely filters may be more economical. Once you know the colour temperature of your light source, and that for which your film is balanced, you can select a filter to give you a neutral colour balance. Basically, you use bluish filters to raise the colour temperature, or amber ones to lower it. It is immaterial whether the filters are placed on the light source or on the camera lens.

Mired shift system

Colour temperature is not a linear scale. A filter changes the colour temperature by a different amount on different places on the scale. For example, a filter for taking pictures in daylight on Tungsten light film (type B) alters the colour temperature from 5500K to 3200K (i.e. by 2300K): the same filter alters tungsten light only from 3200K to about 2250K (i.e. by about 950K).

The mired scale is calculated from the colour temperature by dividing the kelvin figure into one million:

$$\text{Mired value} = \frac{1\,000\,000}{K}$$

This gives a roughly linear scale. Each filter can be assigned a mired shift value. This is the change in mired value that the filter accomplishes at any point on the scale. The shift value may be expressed as:

$$\left(\frac{1}{K2} - \frac{1}{K1} \times 10^6 \right)$$

where K1 and K2 are respectively the colour temperatures of the light source and the light transmitted by the filter.

The mired shift value is positive for yellow or amber filters, because they lower the colour temperature, thus raising the mired value. Conversely the shift value is negative for bluish filters.

Mired shifts give only an approximate guide to colour temperature change. For accurate work, there is no substitute for making a series of tests. However, the mired system is quite adequate for most general photography.

Filter manufacturers supply tables from which you can find the filter you need to convert from one colour temperature to another. These tables cover most of the commonly encountered light sources and the normally available films. The manufacturers also quote the mired (or

MIRED EQUIVALENTS OF COLOUR TEMPERATURE

K	0	100	200	300	400	500	600	700	800	900
1000	1000	909	833	769	714	667	625	582	556	526
2000	500	476	455	435	417	400	385	370	357	345
3000	333	323	313	303	294	286	278	270	263	256
4000	250	244	238	233	227	222	217	213	208	204
5000	200	196	192	189	185	182	179	175	172	169
6000	167	164	161	159	156	154	152	149	147	145
7000	143	141	139	137	135	133	132	130	128	127
8000	125	124	122	120	119	118	116	115	114	112
9000	111	110	109	108	106	105	104	103	102	101
10000	100	99	98	97	96	95	94	93	93	92
11000	91	90	89	89	88	87	86	85	85	84
12000	83	83	82	81	81	80	79	79	78	77

decamired, i.e. mired/10) shift values of their filters. If you subtract the mired value of the light source you are using from the value for the light-source for which your film is balanced, you have the value of the shift. Remember that a positive shift means that the light you are using has too high a colour temperature — needing a yellowish filter; and a negative shift means your light-source has too low a colour temperature, and you need a blue filter.

Photographic Filters and their Names

A host of manufacturers supply photographic filters in almost bewildering profusion. No book can hope to list them all, or give all the alternative numbers for any particular filter. Where it is necessary to define a filter more or less exactly, we have used Kodak's Wratten numbers. Filters used to alter colour temperature are also given their decamired shift values where applicable. Other suppliers will — in most cases — be able to identify their equivalent numbers. There are, however, a number of general names used for groups of filters: they are defined below. The precise function of the filters listed in this chapter are discussed in the following chapters.

Colour conversion filters

These are the filters used to give a basically neutral colour balance when exposing a colour reversal film in a light-source other than that for which it is balanced (see page 48). They come in two series: amber (red) filters for exposing artifical light films in daylight, and bluish for daylight films in artificial light. Each filter is designed for a specific type of film in a specific light source.

As well as with reversal films, they are also recommended for use with professional motion picture negative films. They may be labelled artificial-daylight, daylight-artificial, A-D, D-A etc. Some manufacturers also produce a filter to give more or less successful photography under fluorescent tubes. A system used widely in Europe is to label colour conversion filters with their decamired values, i.e. the mired value divided by 10. Thus a filter which reduces colour temperature (raises the mired value) by 15 mireds is called an R1.5 (red). One which increases the colour temperature (reduces the mired value) by 60 mireds is called a B6 (blue).

COLOUR CONVERSION FILTERS, WRATTEN NUMBERS AND DECAMIRED VALUES

Illumination	Daylight, Type S films	Type A, Type L films	Type B films
Daylight etc. 5500 K	—	85 (R11)	85B (R13)
Clear flashbulbs 3800 K	80C (B8)	81C (R4)	81C (R4)
Photolamps 3400 K	80B (B11)	—	81A (R2)
Studio lamps 3200 K	80A (B13)	82A (B2)	—

Studio filters

Approximately equivalent to conversion filters, studio filters are rolls of acetate or polyester base used to alter the colour temperature of studio lights or windows. They are almost essential if you have to mix large light sources of different colour temperatures. Filters are normally given names to indicate their purpose. For example, WF Green is a green filter used over white-flame carbon arcs to approximate daylight.

Light balancing filters

Much paler than conversion filters, light balancing filters are used to make much smaller corrections to colour temperature. Some of them are designed for converting from one common light source to a closely related source. Others can be used following mired shift calculations (see page 36). The amber (red) filters (81 – series) are used to give a warmer rendering in some daylight conditions.
The blue filters (82 – series) may be used to give a cooler rendering in morning or evening light. Manufacturers normally attach mired shift values to these filters, as well as suggesting their uses.

Colour compensating filters

These are designed for making colour prints from negatives or transparencies (see page 182) and provide red, green, blue, cyan, magenta and yellow filters in a range of pale densities. They are manufactured in the highest optical qualities, and may be used in the image-forming light beam (e.g. held between a an enlarger lens and the baseboard). Colour compensating filters are equally suitable for making subtle alterations to the overall colour on transparency films. Professional photographers regularly use such filters over the camera lenses to give 'fine tuning' to the colour balance, especially to compensate for batch-to-batch variations (see page 81).
Colour compensating filters are usually labelled with their colour, and their peak density to their complementary colour (measured at the wavelength of their maximum absorption). Thus a CC20M filter is a magenta filter with a density of 0.20 to green light.

Colour printing filters

Colour printing filters are similar to colour compensating filters, but are not manufactured for use between the lens and baseboard. They are suitable for use in the enlarger head — usually in a specially constructed filter drawer. Colour printing filters are less costly than colour compensating filters, but because they are not checked for optical quality, they cannot be recommended for use over a camera lens. They are not always available in so great a range of colours.

Ultra-violet absorbing filters

Because photographic materials are sensitive to ultra-violet radiation, there are many situations where improved pictures can be made if an ultra-violet (UV) absorbing filter is used (see page 62). Excessive UV can cause a blue cast in colour pictures, and can accentuate atmospheric haze in any picture. UV absorbing filters may be water clear in which case they are usually called simply UV; or a faint salmon colour, called skylight. This is the Wratten 1A Type (see page 62). Almost all yellow orange or red filters absorb UV.

Haze filters

Black-and-white pictures taken on hazy days can be rendered clearer by restricting the light to longer wavelengths, which are not dispersed as much by the haze (see p. 100). The yellow Wratten 2B or 2E filters are intended for this; but for greater penetration, orange, red, or even visually opaque infra-red filters may be used (see page 138).

Correction filters

The spectral sensitivity of panchromatic films does not exactly match that of the human eye. Blue objects tend to come out lighter on the film than we see them. This effect can be countered in daylight with a yellow filter. Such filters are sometimes called 'sky filters' or 'cloud filters' because their main use is in making white clouds stand out against a blue sky. Stronger yellow filters may be used to exaggerate

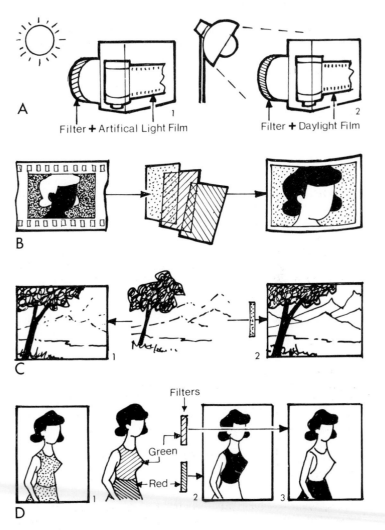

Common uses for filters. A, Balancing a film for a different type of lighting. B, Colour printing. C, Penetrating haze 1, without filter 2, with filter. D, Contrast control 1, without filters, 2 red filter, 3, green filter.

the contrast. Because tungsten illumination is rich in red light, a yellow-green filter (which absorbs some of the red as well as blue) is used to give correct tone rendering on panchromatic film with such lights. Some high speed panchromatic films are excessively sensitive to red light, and a blue or green filter may be needed with them.

Contrast control filters

Coloured filters absorb specific colours of light. A coloured object appears darker if photographed on panchromatic film through a filter which absorbs that colour (see page 94), i.e. a filter of complementary colour. If the exposure is increased to compensate for the filter's absorption, objects the same colour come out lighter. Thus careful choice of filter can render colour diferences as tone differences in monochromatic pictures; so strong coloured filters are often known as contrast control filters (see page 96).

Visually opaque filters

Ultra-violet (UV) and infra-red (IR) radiation can be used to take monochrome photographs (see page 125). If the record is to be confined to specific radiation, all other forms, including light, must be excluded from the camera. Visually opaque filters to transmit either UV or IR are readily available. Be careful not to confuse them with UV and IR absorbing filters. Some are not absolutely opaque to light: UV transmitting filters may be dark violet, and IR transmitting filters dark red.

Neutral density filters

Neutral density filters are manufactured to absorb light of all wavelengths about equally. Thus, they reduce light intensity without affecting either the colour rendering or monochromatic tone rendering of coloured objects. Some are manufactured as 'photographic silver density' and are not suitable for use on camera or enlarger lenses (see page 104).

Heat absorbing filters

Heat filters (infra-red absorbing filters) are used in colour printing. They pass all visible radiation, but stop heat and IR.

Safelight filters

Not all photographic materials are sensitive to light of all colours. Safelight filters are designed to restrict illumination to the non-sensitive wavelengths. They are fitted over the lights for general darkroom illumination. The most commonly-used filter is a pale amber colour. This entirely eliminates the violet and blue light to which ordinary bromide papers are sensitive. Film and paper manufacturers specify exactly which filters are suitable for their materials.

Safelight filters are normally made from diffusing materials. This means that they cannot be used on a camera lens, even for special effects.

Viewing filters

It is difficult to assess exactly how a scene will come out in a photograph. Filters (usually non-photographic) are available to help you.

Colour materials tend to compress tonal values. A viewing filter, which reduces the ability of the eye to adapt, allows you to estimate the lighting contrast visually.

Black-and-white reproduction can be approximated visually with a dark olive coloured filter. This reduces colour differences to a minimum, allowing the subject to be seen as a series of tones. The photographic 90 filter is a similar colour, but somewhat less dense, and may be used as an alternative.

Polarizing filters

Polarizing filters differ from all other filters. They restrict the plane of polarization of light rays passing through them (see page 114). The plane can be chosen by rotating the filter. Such filters may be used to suppress or exaggerate any polarized part of the light reaching the camera.

Scientific and technical filters

Filters are used for a wide range of scientific purposes. Their absorption curves are carefully tailored to their function. Some of them are quite pale, and can be used as substitutes for light balancing or colour compensating filters. Others, like most of the filters for black-and-white film use, are strongly coloured. They may be used as contrast control filters, or with colour films to produce special effects. For all of these filters, however, exposures must be determined by testing, because the manufacturers don't give them filter factors.

The most important scientific use of filters for photography is in densitometry (see page 191). For colour work, sets of three (red, blue and green) filters are specially chosen. The exact colours depend on the particular purpose. There are defined standards for measuring from colour prints, printing inks, transparencies, and masked colour negatives. Special filters are also designated for monochrome densitometry.

Graphic arts filters

Many of the most accurately made filters, especially in large sizes, are made for use in photomechanical reproduction processes. These filters are very expensive, and have no special advantages for the ordinary photographer. They are manufactured in a restricted range of colours, all of which are generally available in the normal photographic filter range.

Filter materials

For use on a camera lens, filters must be optically superb. They are normally made from one of three types of flat material: glass, hard plastics, or gelatin. These materials may all be coloured with dyes. The glass and hard plastics filters are often supplied in mounts for fitting to camera lenses. Gelatin filters are much more fragile and suitable only for infrequent use outside a studio. They can, however, be supplied sandwiched between two pieces of glass, in which case they can be treated exactly like glass or hard plastics filters.

Colour Filters for Colour Films

When you use a coloured filter with a colour film, it changes the colour much as you would expect. This is reflected exactly in the final transparency or movie if you use reversal film, but may be altered in the printing stage with negative materials. General purpose negative films are normally used without a filter under all conditions. Professional negative films, both still and motion picture, give good results more easily if a filter is used whenever it is appropriate. With reversal materials, of course, you must make all the colour corrections you want by using filters when shooting the picture.

The recommendations in this chapter thus apply basically to reversal films and professional negative films. But you may get better results on some amateur negative films if you use filters.

Colour films

Colour films consist of three separate layers, sensitive to blue, green and red light respectively. During processing, these layers are converted into coloured dyes of the complementary colours. With reversal processing, this conversion takes place in the less exposed parts to give a positive image; and with negative processing it happens in the more exposed parts to give a negative. The exact density and colour depends on the relative densities of the three dye layers in each spot on the processed film. Films are manufactured specially to be suitable either for reversal or for negative processing.

In reversal films, the colour balance of the final picture depends on the balance between the densities of the three layers after processing the camera film. These densities are determined by the original manufacturing specification, by the light which reached the film during exposure, and by processing. For the purposes of this book, we shall ignore possible processing variations and concentrate on the interaction between the film type and the light to which it is exposed.

Colour film balance

During manufacture, the relative sensitivity of the three layers is adjusted to give a neutral colour balance when the film is exposed to light of a particular colour temperature. The reversal films in common use are balanced for one of three types of lighting: Daylight – 5500K, photofloods – 3400K (type A film) and studio lamps – 3200K (type B

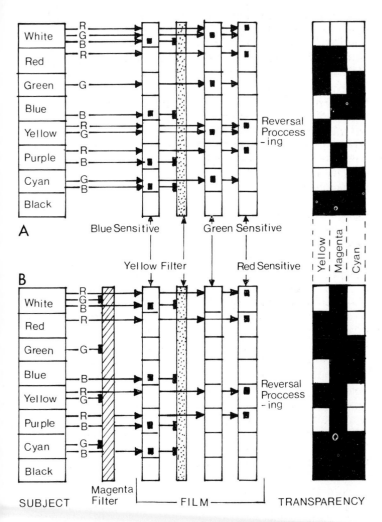

Colour transparency film. A, Blue, green and red light from the subject exposes its appropriate layer in the film. After processing yellow, magenta and cyan dyes are formed in the *unexposed* parts of the three layers to give a natural colour image. B, A magenta filter absorbs all the green light, so after processing all the green-sensitive layer is coloured magenta.

49

film). At one time, type F film was also available; this was balanced to give neutral colour rendering in the light from clear flash bulbs (3800K). Colour negative films made for exposures shorter than 1/10 second (type S) are usually balanced for daylight; colour negative films for longer exposures (type L) usually for tungsten light (3200–3400K). Some amateur negative films are balanced for about 4000K so that they are satisfactory in all light sources.

If they are exposed to light of the wrong colour temperature reversal films will render neutral objects either too yellow-amber, or too blue. This deviation from neutral colour is called a *colour cast.* Thus a too blue slide is said to have a blue cast. The rendering can, however, be returned to neutral with a suitable filter. Negative films exposed in inappropriate light are difficult to print.

Colour filters act by selectively reducing the red, green or blue light and thus (on reversal film) selectively increasing the density of the cyan, magenta or yellow images respectively. So, a yellow filter reduces blue light reaching the film. This increases the density of the yellow dye image formed on processing, therefore making the picture more yellow overall.

The colour change is due to the selective effect that the filter has on the exposure of the three layers. But for most purposes, you can simply think of the filter as altering the overall colour of the processed film.

Filters for daylight films

Daylight films are balanced for light with a colour temperature of about 5500K. They produce neutrally balanced transparencies if exposed to normal daylight, blue flash bulbs or electronic flash. Daylight is about the right colour on sunny or cloudy-bright days when you take pictures in the sun. For about two hours after dawn and before sunset, the light tends to be too yellow, and on dull days rather too blue. The next chapter details the filters which may be needed in these conditions.

Filters are used to give a neutral colour balance when taking pictures in light of other colour temperatures: different colours are used for each type of lighting.

Studio lamps (3200K) are the most amber lighting recommended for photography. These may be ordinary tungsten lamps or the newer tungsten halogen type. The Wratten 80A (B13) filter is needed. This is a deep blue colour and needs an exposure increase of two stops to give correct density pictures.

Photolamps (3400K), such as photofloods, need a slightly paler filter the Wratten 80B (B11). This demands a 1⅔ stop exposure increase.

Clear flashbulbs are made with various fillings to give slightly different coloured light. The two most widely used are aluminium-filled (4200K) and zirconium-filled (3800K). For aluminium-filled bulbs, a Wratten 80C (B8) filter is recommended, needing a one stop exposure increase; for zirconium-filled bulbs, use an 80D (B6) filter, with ⅓ stop increase.

Most small flashbulbs have a blue coating to make them suitable for daylight films without a filter.

Carbon arcs are available in two forms — white flame arcs (5000K) and low-temperature arcs (4000K). White-flame arcs can be converted to daylight film balance with a pale green filter which also absorbs UV. Usually a studio type filter is fitted over the light-source for this purpose. Low-temperature arcs have characteristics similar to clear flash-bulbs, and an 80C or 80D (B8 or B6) filter should prove satisfactory.

Fluorescent tubes have a discontinuous spectrum (see page 24) that makes it difficult to get good colour pictures. Each type of tube has a slightly different colour, and the best filters can be found only by experiment. If you don't know the tube type, try daylight-type film with bluish-white tubes and use a red or magenta filter. A CC30R, R3

STARTING POINTS FOR TAKING COLOUR PICTURES WITH FLUORESCENT LIGHTING

Type of tube	Type of film	
	Daylight/colour neg†	Tungsten type A*
Daylight	30R + 10M (1 stop)	85 + 20M + 10R (1 stop)
Cool white ‡	30M (⅔ stop) 20M + 30C (1 stop)	50R (1 stop) 10R + 10Y (stop)
White	20C + 30M (1 stop)	30R + 10M (1 stop)
Warm White‡	40C + 40M (1⅓ stop) 60C + 30M (1⅔ stop)	10R + 20M (1 stop) None

†For type B films add a CC10Y filter. A special filter (FL–A) can substitute for an 85 + about a 20M or 30M.

*A special filter (FL–D) can substitute for about a 30M or 30R filter.

‡As these tubes vary from maker to maker, filters anywhere between the two recommendations may be suitable.

or CC30M is usually about right. Try a 50R (R5) with artificial light film. Alternatively, some manufacturers make special filters for this purpose. These are labelled with their purpose, or given letter codes such as FL-D for use with daylight film, or FL-A for artificial light film. With warmish white tubes, you may be successful using a tungsten light type film and no filters. Whatever you starting point, if possible take trial pictures to determine exactly the combination of filters to give the colour balance you need.

In most cases, if you have to take colour pictures with fluorescent lighting, it is better to use negative film. If you do, you can use the special fluorescent light filter to help overcome the discontinuous spectrum. Final colour corrections can be made at the printing stage.

Filters for artificial light films

Artificial light films are balanced for exposure by tungsten lamps, either 3200K studio lamps, or over-run 3400K photolamps (such as photofloods). 3200K films are called type B, and 3400K films type A. Filters are needed when using a different light source.

Daylight, blue flash or electronic flash (5500K) all need the same filters. A Wratten 85 (R11) for type A film and a Wratten 85B (R13) for type B film. The 85 filter is also used with type L negative films in 5500K illumination. Super-8 movie cameras have an 85 filter built in because most Super-8 film is balanced for 3400K illumination. Both 85 and 85B filters require $2/3$ stop more exposure.

In some cases, especially in professional movie work, slightly paler amber filters, such as a Wratten 85C (R8) are used. This retains some of the blue character of the light.

Carbon arcs of the white-flame type need a strong orange filter to convert them to 3200K. A yellow filter does this for low-temperature arcs. Specially prepared studio filters are available to fit over the lamps for these purposes. They can then be used with type B film (or type A film and an 81A (R2) filter on the camera).

Clear flashbulbs are considerably less yellow than either type of tungsten light. The filter most commonly used with artificial light films is the 81C (R4). This amber filter, which requires an exposure increase of $2/3$ stop gives an acceptable colour balance in most cases. *3400 photofloods* are more blue than the balance of type B films. An 81A (R2) filter is recommended for the correction. This needs $1/3$ stop extra exposure.

3200K studio lamps give a neutral colour balance on Type A film if a pale blue 82A (B2) filter is used. This also needs ⅓ stop extra exposure.

Fluorescent lighting with its discontinuous spectrum, poses with artificial light films the same problems that were discussed on page 51.

Type G film

The most marked effects of changing colour temperature are on the ends of the spectrum. High temperatures result in a preponderance of blue light, and low temperatures in an excess of red. Type G colour film is made with reduced sensitivity to both the far blue and the far red. Thus, with a truly neutral balance produced somewhere about 4500K, this film gives acceptable colour balance in most commonly-encountered light sources. Its slightly amber rendering of tungsten lit scenes gives them quite an acceptable 'warmth'.

This film is intended primarily for the casual movie photographer. It cannot give such accurate representation of brilliant colours as a normal reversal film used in the recommended lighting, or with the recommended filter. If you use type G film, you may find that filters calculated on a mired shift basis (see page 36) will improve the colour balance in some lighting conditions.

Colour negative films

The colour negative films in common use are intended for exposure to daylight or an equivalent light source. Most of them, however, give reasonable negatives in light of lower colour temperature. The colour balance is restored to neutral at the printing stage. This may, however, result in a distortion of colours at either end of the spectrum.

Films made for professional and motion picture use are balanced for specific light sources. They should normally be filtered in the same way as transparency films. If this is not done, a good laboratory may be able to produce acceptable prints, but it is considerable extra trouble.

Almost all still negative films (type S) for normal exposure times — shorter than ¹/₁₀ second — are balanced for daylight exposure. Films designed for longer exposures (type L) are usually balanced for

tungsten light exposure (3400K) as are some motion picture film stocks.

Because some correction can always be made in the printing stage, the exact choice of filters is not critical. For example, almost any of the blue filters used with daylight films will suffice when exposing daylight type negative film in tungsten light. Also, the detailed recommendations in the next chapter have little use with negatives. You may find that you can get more pleasing pictures if you use a blue filter when you expose amateur-type colour negative films in tungsten lighting. This does, however, need a large exposure increase, and may thus be impractical.

One film for all lighting?

Some negative films may be used without filter in all light sources, and so may one type of reversal movie film (Ektachrome type G). When it comes to other films, you need to use filters in some conditions. If you choose one film to be used (with filters as necessary), in all conditions, choose an artificial light film. The exposure increase demanded by a blue filter (for daylight films in tungsten lighting) is much greater than that needed with amber filters (for tungsten light films in daylight) of equivalent mired shift.

The choice between a type A film or a type B film depends on the light-sources you may want to use and on the availability of films. As the filters to convert from one to the other are quite pale either type of film is suitable for both types of lighting. Thus you can choose the film of the most suitable speed to your purpose.

Mixed light sources

Whatever type of colour film you are using, you will get strange colour effects if you use mixed light sources. The parts lit by a high colour temperature source will be coloured blue, and those by a low colour temperature, orange. These effects cannot be removed either by using a filter on the camera lens, or during printing from a negative. Thus, except for special effects, you must make sure that *all* of the light falling on your subject is of the same colour temperature. For fill-in in daylight, you should use a blue flashbulb, or an electronic flash. With artificial light sources, make sure that all are the same colour. If

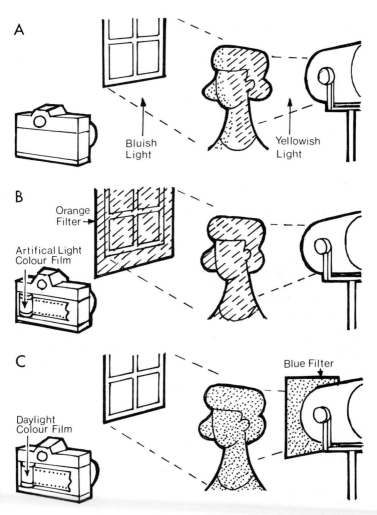

A

Bluish Light

Yellowish Light

B

Orange Filter

Artifical Light Colour Film

C

Blue Filter

Daylight Colour Film

Mixed light sources. A, No film can remove the differences between blue- and yellow-coloured parts of the subject. B, You can put an orange filter over the daylight source and use tungsten light film or: C, you can put a blue filter over the tungsten light and use a daylight film.

you are using different types of light source, you must adjust them all to one colour temperature — and use a filter on the camera as well if you need it.

Filters for light sources

The effect of a filter is exactly the same whether it is fitted over the camera lens, or in front of the sole light source. If you are using a small light source, such as an electronic flash, you can fit filters intended for camera or enlarger use. For larger light sources, there are large sheets of filter. Some is made especially for photographic use, and has specific colour-temperature converting functions. Filter materials for stage use are designed to produce visual effects. Their photographic use is also best confined to special effects; but by trial and error you could find colours suitable for light source conversion.

Studio filters are manufactured mainly for motion-picture studios, but are equally suitable for still colour work.

Blue filters are made to convert 3200K lamps to daylight. They are supplied in full, half and quarter strengths, allowing subtle alterations to colour.

Orange filters convert daylight to match 3200K lamps. Again they are available in a number of strengths. As they are basically for movie use, the colours are matched for using over white-flame carbon arcs; but they are quite suitable for fitting over studio windows to colour the daylight.

Green and yellow filters are also made especially for converting carbon arcs to mix with other light sources. These are used only in the motion picture industry.

Neutral density filters reduce the light intensity without altering its colour. They may be used to reduce the intensity of light source within the picture (see page 112) or to alter an otherwise unwanted lighting ratio.

Filters for mixed lighting

Suppose you have a studio daylit overall, and you want to use a tungsten lamp as a key light. There are two ways you can use studio filters—

1 Cover the windows with sheets of orange studio filters. This

allows you to use type B (tungsten) film without a filter (or as a last resort to use daylight film with a blue filter on the camera).

2 Better, cover the tungsten lamps with sheets of blue studio filter to match the daylight. You can then use daylight-type film (or tungsten light film with a filter). Filtering the tungsten light is the only sensible solution with short exposure professional negative films (type S). You are unlikely, with already filtered daylight, to have enough light for exposures shorter than 1/10 second with the effective film speed of about 25 ASA (through a strong blue filter).

Using coloured light

When you come to colouring lights for special effects, you can use any form of transparent (or even translucent) material over them.

If you use strong colours, they will come out about the right colour whatever you do. If, however, you use pastel shades, you have to use light sources for which your film is balanced. Even so, sometimes the film won't react in quite the same way as your eyes. So if you want an exact colour in your final picture, you have to make test exposures with your chosen film and filters.

Another problem crops up if you are using negative material. Commercial printers try to give your prints an overall neutral colour balance. This causes enough problems if you have large areas of naturally occurring bright colours. If your colours are artificially produced, the operator will be quite unable to decide what colour your prints should be. So, for brilliant colour effects, you have to use reversal films, or have your negatives printed by a specialist laboratory (if you don't do them yourself).

Getting the
Colour
Just Right

The filters discussed in the last chapter are used to correct mismatches of film and light source. However, there are numerous cases in which nominally matched combinations produce pictures that are not quite the right colour. This may be due to slight deviations from the expected colour temperature or composition of the light. Colour casts may also be caused by manufacturing variations in the film. The exact colour of a picture can also be influenced by the camera lenses. Lenses from one manufacturer are likely to be quite similar in colour, but those from different sources may vary slightly. You can determine approximately the colour of your lenses by looking through them at a sheet of white paper. If they are markedly different, you may have to make some tests to see how each of them affects colour films. Colour rendering can be greatly improved with a suitable filter. Some are made specially for the purpose, but often filters intended for other purposes can also be used for subtle colour correction.

Whatever the cause of a colour cast, the filter recommendations suggested here will give a more neutral colour balance. The exact requirements depend on the conditions, and you learn to choose exactly the right filter only by a combination of experience and testing. Also, you may not want to lose the natural colour of the lighting. For example, part of the charm of an early morning shot can be the golden colour of the sunlight. Remember, however, that your eyes compensate for colour at the time and you may need to half-compensate with a pale filter to make a picture as you saw the scene. If possible, take several transparencies through a series of filters.

Slight colour casts are equally common when using a film and filter combination to match the light source. Thus, in most cases, the filters suggested in this chapter may be used together with a conversion filter. If the extra filter acts against the effect of the conversion filter (for example, if you need to add a blue filter to an amber one) you may get better results with a paler conversion filter.

Using more than one filter is discussed on page 86. The use of a UV-absorbing filter, however, is unnecessary with most yellow or amber filters, because they do not transmit ultra-violet radiation.

Naturally, because negative films go through a printing stage, the precise corrections discussed here apply only to reversal films.

Daylight films in daylight type lighting

The quality of daylight — formed as a mixture of sunlight and skylight —

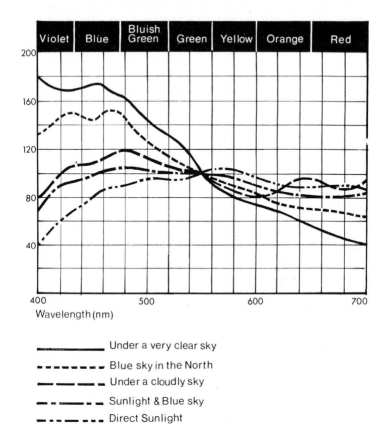

| Violet | Blue | Bluish Green | Green | Yellow | Orange | Red |

Wavelength (nm)

——————— Under a very clear sky

▪ ▪ ▪ ▪ ▪ ▪ ▪ Blue sky in the North

—— —— —— Under a cloudly sky

—▪—— ▪ ▪ Sunlight & Blue sky

—▪▪—— ▪▪▪ Direct Sunlight

The colours of natural light. The distribution of wavelengths in daylight varies its colour from the strong blue of a clear sky to the slight yellow of direct sunlight.

varies from place to place, from month to month, and throughout the day. Daylight films give a neutral balance when exposed to light of about 5500K. This is about right for noonday sun anywhere in the world; and gives good pictures whether the sun shines directly, or is diffused through thin clouds.

In hazy weather, or close to large areas of water or snow, the radiation contains more ultra-violet rays than the film can cope with. This results in transparencies with an overall blue tinge (cast). This colour is especially obvious in the distant parts of the scene. An ultra-violet absorbing (UV) filter on the camera lens reduces this. It does not, however, make any difference to colour casts caused for other reasons.

Skylight, that is, the blue light reflected from a clear sky (without added sunlight) is a strong blue: its colour temperature can be as high as 20 000K. This is especially obvious in winter scenes, where shaded parts of snow come out a strong blue. The blue colour, however, shows whenever you take pictures in the shade on sunny days.

Most manufacturers supply a skylight (1A) filter. This is a pale salmon colour. It absorbs UV and makes pictures slightly warmer in tone than a simple UV filter. It is intended to counteract the blue of skylight on pictures taken *in the sun* on very bright days. Many photographers keep a skylight filter permanently mounted, as they prefer transparencies taken through it. Skylight filters absorb so little light that they necessitate no exposure increase; and they are so pale that they have virtually no effect on subjects lit only by skylight.

For objects in the shade you need one of the Wratten 81 series of filters. They are nowhere near dense enough to give a true mired shift conversion for pure skylight, but even in the densest shade, much yellow sunlight dilutes the blue. The 81A, 81B or 81C (R2, R3 or R4) filters usually prove adequate. Some manufacturers call their filters for this purpose 'red' or 'orange'. An R1.5 filter is another popular recommendation. The only way to decide which is most suitable is to make tests; or take pictures through each one, and then select the most pleasing.

In cloudy weather unless the clouds are very thin, the light tends to be on the blue side. The colour temperature varies from about 6 000K to over 8 000K. You will often get more pleasing pictures in such conditions if you use an amber filter. The 81A (or an R1.5) is usually the most successful.

In the morning and evening, especially if the subject is in direct

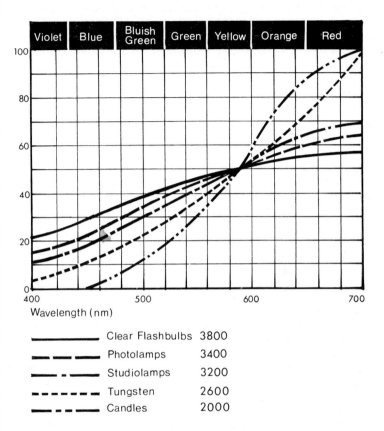

Violet	Blue	Bluish Green	Green	Yellow	Orange	Red

Wavelength (nm)

Clear Flashbulbs	3800	
Photolamps	3400	
Studiolamps	3200	
Tungsten	2600	
Candles	2000	

The colours of artificial light. The distribution of wavelengths in various artificial light sources give them their characteristic colours. These vary from the yellow of clear flashbulbs to the orange-red of candle flames.

sunlight, light is much more golden than at other times. This will show, and may be obtrusive if the picture does not depict the time of day. You can get a neutral colour balance by using a pale blue filter. The 82A (B2) is usually about right. But do remember that the warm colour gives much of the charm to pictures taken when the sun is low in the sky.

Electronic flash guns may give light with rather too high a colour temperature, or be rich in ultra-violet radiation. Small modern guns often have gold-coloured discharge tubes or coloured lenses. These give an ideal colour balance on most daylight type films, but older and larger guns may give a bluish cast. This can be removed by using a pale yellow or amber filter. A 1A, 81, 81A, 81B or CCIOY will probably be successful; alternatively, an R1 or R2 may be right for your flash.

If you find that a filter is useful, the best place for it is on your flashgun. You can fix a gelatin filter permanently over the light window. (If you have a 'computer' gun do not fit the filter to cover the sensor.) This means that your light is always the right colour, and you don't have to worry about whether or not you have a filter for each of your camera lenses.

Blue coated flashbulbs are made to give a colour temperature of about 5400K, and can be used without filter for most colour films. Flashcubes and Magicubes, however, have a slightly lower colour temperature (about 4950K). They are intended to give a slightly warmer colour rendering. If you don't like it, you need to use a pale blue filter, such as an 82, 82A or CC10B (otherwise a B1 or B2).

Tungsten light films in closely matched lights

We discussed exposing type A and type B films in each other's light sources in the last chapter; but there are many other types of artificial light. Each has its own characteristics.

Household lamps and other general service tungsten bulbs generally have a lower colour temperature than photographic light sources. Theoretically, they need pale blue filters if they are to give exactly the right colour balance. An 82B or 82C (B3 or B5) filter is indicated with fairly powerful bulbs (75–150 watt). In practice, as long as you give enough exposure, type B films can give quite reasonable results in strong household illumination. Naturally, such a technique is acceptable only for informal pictures; and normal bulbs cannot be considered a substitute for proper studio lights.

Colour film reproduces scenes in their natural colours. Black and white film makes pictures as a series of tones. These can be altered with filters — see Page 129 — *Hoya.*

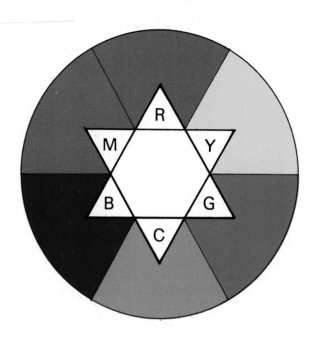

The colours of the spectrum can be set out in a colour circle. The primaries, red, green and blue mixed together form the secondaries, cyan, magenta and yellow.
Opposite: Light from the sun can be regarded as made up from the three primaries, red, green and blue. These are reflected in different proportions from a coloured subject. A yellow filter absorbs blue, and a red filter absorbs blue and green.
Bottom: A white subject photographed through green, red and blue filters – *Hoya.*

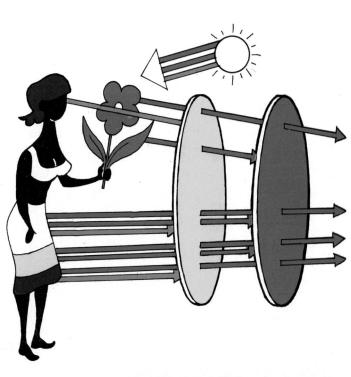

Filters can improve the colour of transparencies. Left hand pictures without filters.
Top: An R6 filter gives a warmer more neutral picture of a snowy mountain – *BDB.*
Above: An 81A gives a cooler rendering in morning light – *Hoya.*
Opposite: Stronger filters are needed if the film is not balanced for the light source.
Top: An 80B for daylight film in photoflood lighting.
Centre: An 85B for type A film in daylight – *Kodak.*
Bottom: An FL-D for daylight film in fluorescent lighting – *Hoya.*

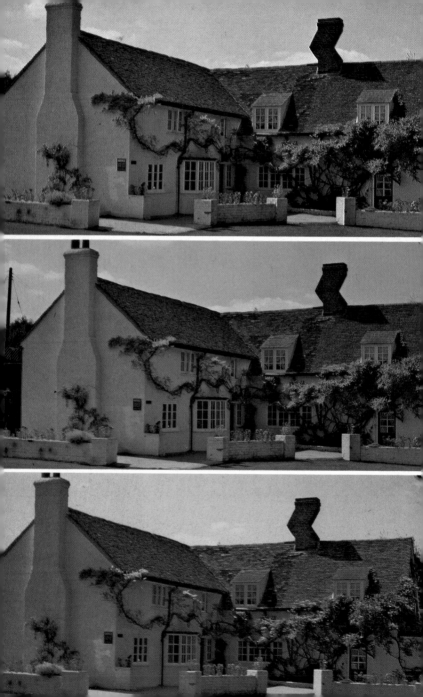

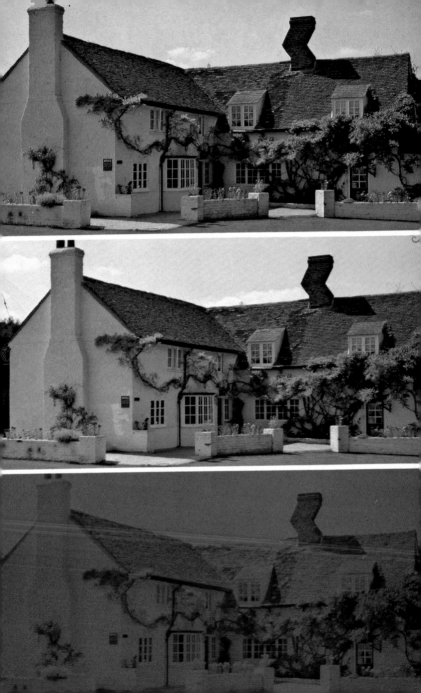

Strong coloured filters can be used for effects.
Red and cyan filters on the lights create an effective darkroom scene – *Kodak*.
Opposite: A strong yellow filter gives this into-the-sun picture a little extra – *Neville Newman*.
Page 70–71: A normal daylight scene coloured by being photographed through each of five BDB coloured filters. *Top left* no filter, *top right* blue, *centre left* yellow, *centre right* green, *bottom left* orange and *bottom right* red.

Front-of-lens attachments can change the focusing range of a set-up.
Top: An obtrusive background can be suppressed with a wider lens aperture. A neutral density filter reduces the exposure to the original level — *Hoya.*
Bottom: Focused on a close-up, the background is always blurred — unless you use a split-field close-up lens. This lets you picture a sharp foreground subject and a sharp background — *BDB.*

Polarizers alter tones in colour pictures without changing the colours – *BDB pictures.*
Top: In some scenes, a suitably oriented polarizer can provide considerable haze penetration.
Bottom: Absorbing reflections (from a suitable angle) can considerably increase the saturation in pictures of shiny subjects.

A diffusion screen over most of the picture area softens away the background, leaving the central subject quite sharp – *Peter Styles.*
Opposite: A star screen on the camera lens adds extra sparkle to a backlit scene – *Kodak.*
Page 78 top: This attractive and unusual portrait was made with a simple lens mounted on a 35 mm SLR. A cross-shaped diaphragm gave extra sparkle to the highlights. The colour came from using daylight film in tungsten lighting – *Jeff Manon.*
Bottom: A five-faceted prism gives four extra images round the central one – *Hoya.*
Page 79: Reeded and other patterned glass can be used to striking effect in colour or black and white – *Neville Newman.*

False-colour infrared colour film produces strange unnatural colours. It has turned this aerial shot of Hyaleah race course into a fantasy world – *Kodak*.

Kerosene lamps, candles, firelight etc. are much redder than household lamps. Most have a colour temperature below 2000 K. They cannot be considered as suitable colour photographic light sources, because to get a neutral colour balance you would need a strong blue filter (about a B20). Such a filter, denser than an 80B would need about 3 stops extra exposure, and thus exposures would be ridiculously long with such dull light sources.

Despite this, you can take attractive pictures with such lights — usually including them in the picture. The red-orange results can convey far more atmosphere than would a clinically neutral picture.

Testing colour materials

Getting exactly the right colour balance first time is especially important to the professional photographer. Professional reversal films are batch numbered, and given exposure and filter recommendations for a satisfactory colour balance. Even so, to be quite sure of the colour balance of any film, you must first test the *batch* you are using. For this precision, naturally, you must buy large quantities of the same batch, and store them with great care (in a refrigerated store). Even if you don't want to work in this way, you may test your equipment and surroundings to choose filters to give you the best results on the film *type* you choose.

When making test exposures, use your customary equipment and lighting. Include in your picture a subject of your normal type, a neutral grey test card, and a set of bright colour patches. Also, include a card giving exposure and filter information about each shot. Take your first picture at the recommended exposure setting, with any filters that may be needed (e.g. film recommendation, colour correcting, flash correcting etc.); take pictures with one stop more and one stop less exposure; then take six pictures at the correct exposure through each of the six colour compensating filters with a density of 0.1 (CC10R, CC10G, CC10C, CC10M and CC10Y). You can use the rest of the film to take combinations of filters and exposures, or simply pictures in which the colour balance is not too critical.

As soon as possible have the film processed correctly (or process it yourself). Examine the transparencies carefully in the way you normally view your pictures, and choose the one which you like best. If you would prefer a colour midway between two of them, use one or two 0.05 density filters to meet your needs. Once you have decided

which filters to use on your camera, or over your flash guns, to give a neutral colour balance, you will have the remaining filters for making subtle changes to suit the mood of your pictures.

If none of your test pictures please you, you can still use them to determine the filters you need. A filter reduces a cast of its complementary colour. Thus, if the best picture is still too green, you need more magenta filtration. Try looking at your transparencies through appropriate colour compensating filters. This can give you a good idea of what the filters will do if you use them on the camera. In fact, you will need rather less colour than this suggests. If a CC10M filter makes your test transparency just right, try another test with that filter added to whatever you used before; and with a CC05M instead. Probably the paler filter will give you the result you want.

Measuring the colour of lights

Occasionally, you may come across a light-source of unknown colour temperature. To get a neutral colour balance, you must use filters determined either by test films, or with a colour meter. Colour meters measure the colour temperature of a light-source. They do this by comparing the light intensity through red and blue filters (or other suitable filters).

One typical meter has four overlapping kelvin scales for red/blue colour temperature – which approximates to the colour temperature of photographic light sources – and a scale of red/green colour temperature. It is used as a normal incident light meter (and can in fact measure light intensity), and the colour temperature is read off a scale. Meters are usually calibrated in kelvins and mireds. They may have a calculator dial for direct determination of the required colour correction or light balancing filters.

If you can determine the colour temperature of a light source, it is quite simple to calculate the conversion filter you need for any particular type of film. Calculations with mired shift values are discussed on page 34.

Reflected light

Up to now, we have assumed that the light reaching the subject is coloured only by its source (including any filters fitted to that source).

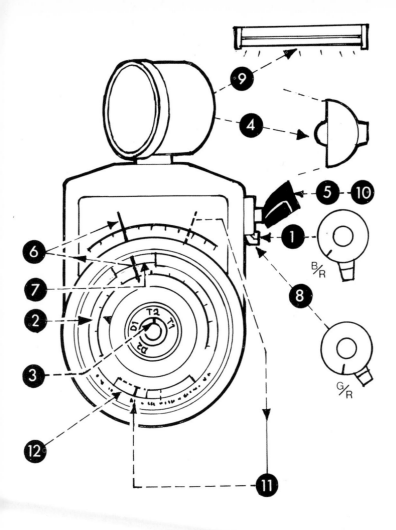

Operating a typical colour temperature meter. 1, Select blue/red scale; 2, set film type; 3, set light source; 4, take incident reading; 5, press switch and release; 6, line up index with needle; 7, read off filter; 8, if necessary then set green/red temperature; 9, this is for special sources; 10, press switch again; 11, transfer figure to scale; 12, read off extra filter.

However, except in carefully controlled studio set-ups, much of the light reaching the subject is reflected from the surroundings. Any coloured object colours the light it reflects.

This colouring may be an advantage. Pale buff living room walls warm up flash photos a fraction, by reflecting some amber-coloured light on to the subject. In most cases, however, coloured reflecting surfaces introduce unwanted casts. Wedding pictures taken on green grass surrounded by spring foliage may show the bride in a lovely pale green dress (darker as it gets nearer the ground); even the groom may look less well than his stag party actually left him.

Like colour casts caused for any other reason, reflected light effects can be countered with a filter of the complementary colour. The greenish wedding pictures call for a magenta camera filter. Probably a pale one such as a CC10M is quite adequate. Experience with your familiar surroundings can tell you what is best. In new situations, if you haven't time for testing you need intuition. Just look for coloured reflectors, and try to imagine how much effect they can have. Then choose a suitable filter of complementary colour. If you can, try different filters, and choose the best pictures later.

To make things that much more difficult, when the ground is wet – or near water or snow – more skylight than usual is reflected on to your subject. This tends to give you a bluish cast, which must be countered with an amber (red) filter such as 81A or R2.

Local colour casts

When your subject is close to a strongly coloured object only part of it may be coloured. Be especially wary of brightly coloured umbrellas and beach towels. You can get quite surprising results if you are not careful. Imagine the reaction when you produce the picture of your girl friend with one bright yellow cheek. You can't do anything about such local reflections with filters. But there are two possible solutions. Move the reflector away from your subject or include it in the picture. A portrait of a girl pictured by a red door may be quite acceptable if you can see the door to explain her strange colour. Without the door, you just have an off-colour transparency or print. Here is one case where it doesn't help you to be using negative film. The colour printer can't change part of the picture without colouring the rest oddly.

Reciprocity law failure

An important assumption in photography is that the effect of an exposure is a product of the intensity of light falling on a film, and the time for which it falls. This is called the *reciprocity law*. Because it works, you can choose any one of a range of aperture and shutter speed combinations to give a particular exposure.

Unfortunately, this law does not hold good for all exposures. Very long or very short durations tend to require either more or less than the predicted light intensity to produce a particular density on processing. The actual factor by which the intensity must be altered depends on the exposure time and on the particular emulsion. This causes some problems with black and white materials, but has much more serious implications in colour photography.

The balance of a colour film depends on the relative density of the three emulsion layers. As the three layers are affected differently by exceptionally long or short exposures, such exposures also affect the colour balance. No normal colour film will behave unusually with *fast* shutter speeds, but some may react adversely with extremely short duration electronic flashes. These effects are unpredictable, and if you are using a 'computer' gun at very close range, you can use a neutral density filter over the flash head (but not the computer "eye") to increase the flash duration. (Alternatively you can use a neutral density filter over the camera lens *and* the computer 'eye'.)

Neither will normal films be affected by exposures shorter than about $\frac{1}{10}$ second. At longer exposures than this, however, the effects of reciprocity law failure may begin to show. To some extent this can be corrected with filters. One maker of several transparency films recommends at least double the exposure, and yellow, green, cyan, magenta or red filters if their various types of film are exposed for longer than 10 seconds. You can get specific recommendations from film manufacturers; these are a reasonable compromise, but should be táken only as a starting point for tests with a particular *batch* of film. If you have to use long exposures, you will have to make a series of test pictures using a range of CC filters and various exposure times.

Colour negative films may also be affected. Changes in the relative contrasts of the three layers can make the negatives incompatible with colour papers. This may result, for example, in prints with magenta shadows and green highlights. No amount of filtering in the camera or in the enlarger can improve this situation. The careful use of negative or positive coloured masks may retrieve a vital picture.

The manufacturers of some small electronic flashguns suggest that the colour of their light is filtered to prevent reciprocity law failure with very short exposures. It is more likely that it is just filtered to suit the colour temperature requirements of films which can cope with very short exposure times. The filters needed to counteract reciprocity law failure with unusual exposure durations would give abnormal colour balance at normal flash durations.

Combining Filters

Often getting the colour just right needs two or more filters used at once. With artificial lights, you may be able to use one type filter on the lights and another over the camera lens. However, in many cases you need to use more than one filter at the same time on the camera. Separate filters, either glass or gelatin are quite satisfactory when used in pairs; but the extra surfaces may produce unwanted reflections. These can be diminished if you use surface coated — or multicoated filters; but more than two filters together are almost always unsatisfactory.

Sometimes the number of filters can be reduced by careful selection, and sometimes by altering film and lighting combinations. For special circumstances where a combined effect is essential, filter manufacturers may be able to produce a suitable single filter. They may alternatively be able to supply any two gelatin colours cemented together between glass sheets to form a single filter.

When you do combine two separate filters, you must add together their exposure increase (whether the colour effects add together or counteract one another). If you use exposure factors, you must multiply them together. Thus if you use a ×4 (2 stops more) and a ×2 (1 stop more) filter, your total exposure factor is 8× (three stops more). Because the exact effect on exposure is determined by the interaction between the two absorption curves, this cannot be regarded as an accurate method of determining the exposure increase needed. It is, however, a good practical base for experiments as long as both the filters are of the normal type used with colour films (see Chapter 12).

Viewing filters

A most important part of lighting for colour photography is the balance between highlights and shadows. Because your eyes adapt

swiftly as they scan from light to shade it is difficult to judge the lighting contrast on your subject. Viewing filters are made so that you have less visual adaptability; and can more clearly see your subject as it will come out on the film. Viewing through such a filter may tell you whether or not you need to use fill lighting in outdoor shots.

Coloured
Filters with
Black-and-White
Films

Black-and-white films record scenes as a range of grey tones. The exact tone produced from an object results from the interaction between the film emulsion and the light from the object. In the simplest terms, the more light reaching the film, the darker will be the processed negative. This is considerably complicated because different types of film have differing sensitivities to light of different colours. None of the sensitivity patterns exhibited by black-and-white films exactly matches that of the eye, but modern emulsions come quite close to this.

Monochrome photography

The grey tones of a black-and-white negative are produced by deposits of metallic silver in varying densities. This silver is formed during processing of the silver halide emulsion. Prints from negatives are commonly made on papers with a similar silver halide emulsion. The exact colour of reproduction depends on the paper and its processing. It can vary from an almost sepia brown to a cold steely black. Sometimes the image is converted to an entirely different colour, or the paper base is tinted. However, whatever colour the final print is made , the scene is reproduced in a range of single-coloured tones on a single-coloured base. The term monochromatic (i.e. single-coloured) is often used to describe black-and-white photography. The effects of camera filters apply equally whatever colour you intend to make your prints.

The earliest silver halide emulsions depended solely on the natural light-sensitivity of the silver salts. They were sensitive to blue light, and to ultra-violet radiation. Scenes were thus recorded in tone densities corresponding to their reflection of these wavelengths only. Parts of the subject coloured bright red or green came out as if they were black. The tones produced by other red, yellow or green objects depended on how much blue or ultra-violet they reflected. Because from white objects only the blue light affected the film, white and blue parts of the scene were often indistinguishable.

These abnormalities of tone rendering were unavoidable. There was little use for filters because they could have little effect on the tone rendering. As the emulsion was totally insensitive to red or green light, even quite pale yellow or orange filters would prevent any exposure. Today, we commonly encounter blue-sensitive emulsions only in work-room materials. Bromide papers and some copying films

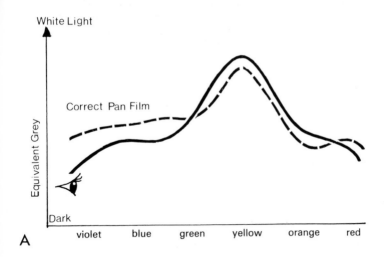

A

White Light

Equivalent Grey

Correct Pan Film

Dark

violet blue green yellow orange red

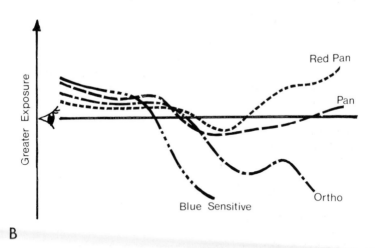

B

Greater Exposure

Red Pan

Pan

Ortho

Blue Sensitive

Black-and-white film sensitivity. A, Panchromatic film matches the spectral response of the eye quite closely. B, If the eye's sensitivity is made a straight line, the different film types are more clearly displayed.

are examples, these may be handled in quite bright yellow safe-lighting without any effect.

Orthochromatic emulsions were the first major improvement. These were made sensitive to green and yellow light by incorporating dyes in the emulsion. The name 'orthochromatic' means true colour, but the films were still insensitive to red rays. Orthochromatic films were distinguished by the suffix 'chrome' in their names — Selochrome and Verichrome were two common brands. Such emulsions gave far more accurate tone reproduction than blue-sensitive ones, but strong red objects still looked as if they were black: one of the most marked effects was the emphasis of skin characteristics and blemishes.

Outdoor scenes on orthochromatic films showed little distinction between blue skies and white clouds. One of the first widespread uses of filters was to correct this. A yellow filter reduced the light from the blue sky to a greater extent than from the white clouds. With extra exposure to account fror the overall light loss, this gave much more striking contrast.

The lack of red sensitivity allows orthochromatic materials to be handled in deep red safelighting.

Panchromatic emulsions have their sensitivity extended to include the whole visible spectrum. Apart from one or two professionally used sheet films, all black-and-white materials now used for picture-taking are panchromatic. The sensitivity to light of each colour depends on the exact specification of films. The human eye is nowhere near equally sensitive to all colours. Emulsion chemists have to try and match this sensitivity to give a true tone representation.

One effect of sensitizing an emulsion to a greater range of colours is to increase its sensitivity, or speed. When red sensitizing dyes became first available, manufacturers produced ultra-fast (over 1000 ASA/31 DIN) films by giving them extended red-sensitivity. Such red-pan films require blue or green filters to give accurate tone renderings. As their use is confined to low light situations, where human eyes are not particularly good at distinguishing tones, such correction is normally superfluous.

Most currently available films are more-or-less matched to the sensitivity of the eye. These are variously called correct pan, orthopanchromatic, or just panchromatic or pan. Their sensitivity to all wavelengths renders them particularly suitable for filter manipulations. Except in special instances, all the black-and-white filter recommendations given in this book are for films with this type of sensitivity.

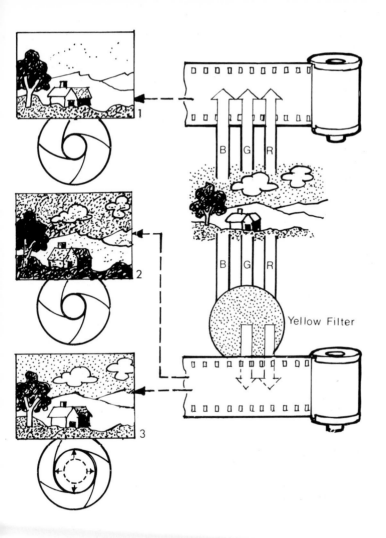

The 'sky' filter. 1, Even correct panchromatic films are over-sensitive to blue and ultra-violet, so blue skies tend to come out white, and clouds don't show. 2, Fit a yellow filter, and everything comes out dark, but the blue parts especially so. 3, Increase your exposure and most of the scene comes out as 1, but the sky is still darker and more realistic.

The effects of coloured filters

Coloured filters can be thought of as acting one of two ways. Dense strong colours hold back all light except their own colour. Paler filters simply absorb some of the complementary colour. The exact performance of any filter can be discovered from its transmittance curve (see page 224). Reducing the amount of light of any colour reaching a panchromatic film reduces the density of its image on the negative. This darkens the density on a print from the negative.

Most things reflect some light of all colours; they are coloured because they reflect slightly more of some wavelengths than of others. So, reducing light of one or more colours reduces the light from most parts of a normal scene. The only unaffected parts of the scene will be those which do not reflect any light of the colours absorbed by the filter. Thus, just putting a coloured filter in front of the camera lens reduces the image density on most negatives. To counteract this effect you need to increase your exposure. This returns the density of most of your negative to what it would have been without the filter. However, the negative is altered in two ways:

1 Those parts of the subject which reflect only light absorbed by the filter do not produce any image.

2 Those parts of the subject which reflect none of the light absorbed produce a darker than normal image.

So, suppose you are picturing bright red roses against a bright green door. If you use a red filter (with appropriate exposure increase), the roses will come out very densely on the negative, and the door hardly at all. Printing from this negative will give you almost white roses against a dark background. Conversely, using a green filter will give you a print of dark roses against a pale ground.

In most natural circumstances, the effects are not absolute. Very few things reflect only pure colours. So, on the whole, pale filters with the appropriate exposure increase lighten subjects of their own colour and darken subjects of the complementary colour. Strongly coloured filters lighten subjects of their own colour and darken subjects of all other colours. The photographer can therefore choose the tone rendering he requires by selecting appropriate filters.

Correcting daylight tones

Panchromatic film records the tones of daylight scenes more or less as we see them. It is, however, somewhat over-sensitive to blue light,

FILTERS FOR BLACK-AND-WHITE FILMS
USED IN DAYLIGHT

Subject	Purpose	Filter Colour	Suitable Type	Increase exposure (stops)
Blue sky (also light subjects lit by blue sky)	Natural	Yellow	6 (K1)/8(K2)	$\frac{2}{3}$, 1
	Darker	Deep Yellow/Orange	9 (K3)/5 (G)/16	1, $1\frac{1}{3}$, $1\frac{2}{3}$
	Very dark	Light red	23A/25 (A)	$2\frac{2}{3}$, 3
	Almost black	Dark red	29 (F)	4
	Special effects	IR/Polarizing	(see p. 114)	
Sunrises and sunsets	Natural	None or Yellow	6 (K1)/8 (K2)	$\frac{2}{3}$, 1
	Brighter	Deep Yellow or red	15 (G)/23A/25(A)	$1\frac{1}{3}$, $2\frac{2}{3}$, 3
Distant scenes	Enhanced haze	Blue	47 (C5)/47B	$2\frac{2}{3}$, 3
	Natural	Yellow	6 (K1)/8(K2)	$\frac{2}{3}$, 1
	Reduced haze	Deep Yellow	9 (K3)/15(G)	1, $1\frac{1}{3}$
	Haze penetration	Red/Deep Red	25 (A)/29(F)	$2\frac{2}{3}$, 4
	Strongest penetration	IR photography	(see p. 141)	
Portraits	Natural	Yellow/Green	8(K2)/11(X1)	1, 2
*Foliage and other greens	Darker	Orange, pale red	16, 23A, 25 (A)	$1\frac{2}{3}$, $2\frac{2}{3}$, 3
	Lighter	Green	11 (X1)/58 (B)/61 (N)	2, $2\frac{2}{3}$, $3\frac{2}{3}$
Reds, oranges, bronzes.	Lighter	Red/Orange	25 (A)/23A/16	3, $2\frac{2}{3}$, $1\frac{2}{3}$
	Darker	Green/Blue	58 (B)/61 (N)/47B	$2\frac{2}{3}$, $3\frac{2}{3}$, 3
Dark blues, purples	Lighter	Blue	47 (C5)/47B	$2\frac{2}{3}$, 3
	Darker	Deep Yellow/red	9 (K3)/15 (G)/25 (A)	1, $1\frac{1}{3}$, 3

*Note that foliage reflects far red and infra-red strongly, so a very deep red filter may make it come out considerably lighter.

and sensitive to ultra-violet (UV) radiation. Blue parts of the scene tend to come out rather too pale in the final print. This effect is most marked as a loss of cloud detail in a blue sky. Sometimes, pale wispy clouds may be lost altogether against a light blue sky.

A UV absorbing filter can improve the situation, but blue areas may still come out too light. The recommended correction filter for pan-chromatic films is a medium yellow, which requires one stop more exposure (a X2 filter factor). The 8 or K2 filter is designed for this purpose.

Because its most striking effect is to increase the contrast between clouds and a blue sky, this filter is often called a cloud filter. If you concentrate on black-and-white outdoor pictures, you may want to keep such a filter permanently on your lenses. Some photographers prefer the slightly paler 6 or K1 filter, which needs $^2/_3$ stop more exposure.

Artificial light correction filters

Illumination from tungsten lamps contains more red light than daylight. It has a lower colour temperature (see page 34). This produces colour balance differences on colour films (see page 48) and differences in tone rendering on panchromatic films. Not only do blue objects come out rather lighter than you would expect, so do red ones; and greens tend to come out darker.

To correct the tone rendering, you need to reduce both red and blue light. So you need a green filter. The 11 or X1 filter is a yellow-green colour suited to this purpose. It is especially useful for giving pleasant skin tones in indoor portraits. It is, however, a strongly coloured filter with a factor of 4, so it needs two stops extra exposure.

Fluorescent lights with their line spectra (see page 24) can give unusual brightness relationships on panchromatic film. The only way to correct this is to make test exposures through possibly suitable filters. With daylight type tubes, a red or orange filter may be useful. Alternatively, a filter designed for using colour films in fluorescent light may help. With warm white tubes, a green-yellow will probably prove suitable.

Contrast control

Imagine two objects – or two parts of a drawing – quite different colours, but the same tone. Our eyes see them as distinctly different because of their colour. Panchromatic film, however, records them as exactly the same grey tone. Such a picture is likely to be quite useless for many purposes. If you want to picture the two parts on a black-and-white film, you have to alter their relative tones.

Coloured filters with suitable exposure compensation alter the relative brightness of different colours on panchromatic film. Thus, the colour difference can be turned to a tone difference by careful filter selection. To choose a suitable filter, look at the subject and

decide which colour appears lighter to you. If you cannot decide, make reds, oranges or yellows lighter than greens, blues or violets. Now choose either a filter of the colour you want to lighten, or a filter the complement of the colour you want darker.

Pale filters give you slight differences, and denser filters correspondingly more obvious ones. Naturally, you must increase your exposure to account for the overall reduction in light reaching the film.

Filter selection is complicated by any other colours in the picture. Suppose you are photographing a poster and want to distinguish between a grey cat and a green surround. You can't use a grey filter, as this will affect all colours equally; so you must use a green filter to lighten the surround, or a red filter to darken it. However, if the poster also includes black writing on a red ground, the green filter could darken the red making the lettering illegible. Thus you are restricted to using an orange, red or magenta filter to darken the green parts. Naturally, if you have also to distinguish the green from a darker colour, your choice is further curtailed.

You can get a reasonable idea of the effect of a filter by looking at your subject through it. If two colours look clearly distinct through a strong-coloured filter, they will probably come out as different tones on panchromatic film. If you can't clearly distinguish between them, they may well come out the same tone. Whenever possible use a range of filters so that you can choose the negative with exactly the contrast you need.

The Wood effect

Plants are green because they contain *chlorophyl*, which is coloured green. Unlike most green substances, chlorophyl does not absorb all red light. It allows the leaves to reflect (or transmit) far red (i.e. the longest visible rays), and IR radiation. You can see this if you use a special dichroic viewing filter, such as a 97. This filter transmits the far red and a little blue to the total exclusion of the green normally seen in plants. Once your eyes become accustomed to the meagre amount of light transmitted, the red light reflected from sunlit plants is quite clearly seen.

The Wood effect is important to the photographer only when he uses deep red or IR filters. It was a significant factor with red pan films (see page 92), which recorded strongly in the near IR. Used with a deep

red filter, these films pictured foliage quite pale. Correct pan films, on the other hand, are unlikely to be affected in normal photography even with dense red filters. The effect, however, is important when using IR-sensitive films (see page 138).

Portraying skin tones

How the skin looks is a very important part of portrait photography. In portraits of young or middle-aged people, you usually want the smoothest rendering you can get. Most facial blemishes are a more or less red colour. They show much less in the picture if you use a red filter. But such a filter also reduces the contrast between red lips or cheeks and the rest of the face. This can be overcome by using strong make-up, but you may lose the natural look of your subject. Generally, an orange or pink filter is satisfactory in difficult cases.

If your subject has excellent skin, you may want to emphasise its texture. A pale green filter is needed for this. The 11 (XI) is ideal, especially in tungsten lighting. Alternatively, you may want to over-emphasise skin characters. Young girls often look especially attractive if they have delicate freckles. 'Character' studies of old people also want skin tone emphasis. For the freckles, a 13 (X2) is probably strong enough. For the old people, a stronger green, or blue-green is useful. Perhaps a 58 (B) or a 44. Some professional photographers use orthochromatic films to attain similar effects.

Copying old documents

Old manuscripts and pictures are often spoiled by yellow or brown staining. Copying these straight on to black-and-white film results in photographs with the information marred by varied grey tones in the background. A yellow or amber filter used on the camera can reduce the effect of the stains. Try to match the filter as closely as possible to the colour of the stains so as to reduce them to the greatest extent.

Blue skies again

The contrast between sky and clouds can be pictured accurately with a mid-yellow filter (see page 93). Often, however, pictures can be im-

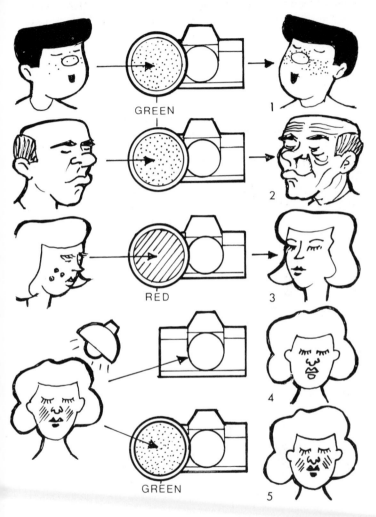

Altering skin tones. 1, A green filter emphasises any red or brown colouration. So you can show up freckles. 2, The same goes for wrinkles in 'character' studies. 3, A red filter suppresses red colourations, so you can use it to mask a poor complexion. 4, Because of its excess red, tungsten light tends to supress facial features. 5, A green filter corrects this.

proved if the contrast is heightened. A stronger yellow filter, such as a 9 or 15 (G) increases the contrast and you may find that it gives you just the effect you want. (The 9 and 15 filters need 1 and 1 $\frac{1}{3}$ stops extra exposure respectively.)

More dramatic effects arise with an orange or red filter. The use of a red filter is apparently contrary to theory. However, as well as reflecting blue light, the sky reflects a higher proportion of green than do the white clouds. By restricting the record to red light you can make the blue sky almost black, while getting the clouds to come out white. In fact, if you use infra-red (IR) sensitive film, and visually opaque IR filter the dramatic effect is greater still.

Suitable orange filters include the Wratten 16 which needs 1$\frac{2}{3}$ stops extra. Red filters can be chosen from 23A (2$\frac{2}{3}$ stops), 25 or A (3 stops) and 29 or F (4 stops).

Whatever the effect you aim at, you can alter only blue parts of the sky. Thus you get greater than normal contrast between the horizon and the sky overhead. The sky close to the sun also comes out much lighter than the parts farther away. Naturally, filters have no effect on an overall cloudy or misty sky.

Haze

Atmospheric haze is formed from dust particles suspended in the air. These small particles reflect short-wave radiation more than they reflect longer wavelengths. Haze scatters almost no IR, little red, some green, more blue, and a large amount of UV radiation. Because panchromatic films are over-sensitive to blue, violet, and ultra-violet radiation, they tend to record more haze than you see at the time.

This may add extra atmosphere to your picture. If such is your intention, you can enhance the effect with a blue filter on your camera. A 47 (C5) or 47B is suitable. They need 2$\frac{2}{3}$ and 3 stops more exposure respectively.

In most situations, however, you want to reduce the haze shown in your picture. You can do this with the filters you use to darken the sky. A light- or mid-yellow makes the picture about natural. The 6 (K1) or 8 (K2), needing $\frac{2}{3}$ and 1 stop extra, are suitable. For greater penetration, deep yellow, orange, red and IR filters are needed. The 9 (K3), 15 (G), 16, 23A, 25(A) and 29 (F) give increasing penetration. (They need 1, 1$\frac{1}{3}$, 1$\frac{2}{3}$, 2$\frac{2}{3}$, 3 and 4 stops exposure increase respectively.) IR filters are discussed on page 138.

Mist and fog, which are composed of water droplets, scatter all wavelengths of light in roughly equal proportions. Because of this, altering the proportions of light reaching your film has little or no effect on misty or foggy scenes.

Using coloured light

Panchromatic films respond to light of all colours, so you can use any colour to light your subject. The effect of photography with coloured light is very similar to that with coloured filters. There is no special point in using coloured lights, except that you can possibly make different contrast corrections in separate parts of the picture.

Because light-meters are not equally sensitive throughout the visual spectrum, you may have some difficulty in determining the correct exposure. If you can, find a filter factor for your colouring media, measure the unfiltered light level and alter your exposure settings to account for the filters.

Viewing filters

Your eyes naturally react to both the tone and the colour of a scene. Panachromatic film reacts only to the tone. A filter that reduces the entire scene to a series of similarly coloured tones allows you to assess the tone balance. The most satisfactory colour for this is dun or olive. Viewing filters of this type are available, but tend to be so dense that you can see little through them. The 90 is a photographic quality filter, slightly paler in colour, which is also suitable as a monochrome viewing filter.

Neutral
Density
Filters

Neutral density filters differ from all other coloured filters by absorbing light of all colours more or less equally. In effect they can be thought of as grey filters. This means that they alter neither the colour balance on a colour film, nor the relative tone reproduction on a black-and-white film. What they do is to reduce the light passing through them. So, if they are put over a camera lens or light source they reduce light reaching the film at any particular exposure setting.

Dispersion coefficients

A number of different substances can be used to reduce light intensity equally across the visible spectrum. One of the simplest is evenly exposed and processed photographic film. Unfortunately, this is totally unsuited for use in an image-forming light beam. The silver grain scatters light passing through, and thus degrades the image.

The scattering is measured as the Callier Q-factor. The closer this is to 1, the less scattering occurs. The Q-factor for photographic silver density is 1.4, making it suitable only for use over light sources or for density measuring.

Three materials have a low enough scattering to be suitable for photographic work.

Colloidal carbon neutral density is the most commonly used. It can have a Q-factor as low as 1.02. This is the form of neutral density assumed throughout this book, but any other photographic quality material is equally suitable. Note, however, that M-type colloidal carbon is a less expensive type of density material. It has larger carbon particles and consequently an unsatisfactorily high Q-factor for use on lenses.

Dye mixtures can also form neutral density. Dyed filters have the same low dispersion factor as ordinary coloured filters. They are ideal for photographic uses, but may change colour slightly on long exposure to bright light. Such a change would not normally affect use, but the filter might not then meet strict criteria of neutrality.

Filters of the highest neutrality are produced by metal-coating a base substance. Metals such as Inconel alloy are deposited in suitable thickness. The coat then attenuates light by both reflection and absorption. Because some of the light is reflected, the filter does not get so hot as it otherwise would. The Q-factor is close to 1 and such filters are used in scientific image-forming systems, particularly for laser work.

NEUTRAL DENSITY FILTERS

Density	Per cent Transmittance	Filter Factor	Exposure Increase (stops)
0.1	80	$1\frac{1}{4}$	$\frac{1}{3}$
0.15	70	$1\frac{1}{2}$	$\frac{2}{3}$
0.2	63	$1\frac{1}{2}$	$\frac{2}{3}$
0.3	50	2	1
0.4	40	$2\frac{1}{2}$	$1\frac{1}{3}$
0.5	32	3	$1\frac{2}{3}$
0.6	25	4	2
0.7	20	5	$2\frac{1}{3}$
0.8	16	6	$2\frac{2}{3}$
0.9	13	8	3
1.0	10	10	$3\frac{1}{3}$
1.2	6.3	16	4
1.5	3	32	5
2.0	1	100	$6\frac{2}{3}$
3.0	0.1	1000	10
4.0	0.01	10000	$13\frac{1}{3}$

Densities and exposures

All neutral density filters absorb light evenly across the visible spectrum, but they absorb different amounts. They are labelled to indicate their density. Different manufacturers use slightly different numbering systems, but conversion is usually fairly straightforward.

Neutral density filters are almost universally given the code ND, followed by a number representing either their density (to light of any colour) or their filter factor. Thus an ND0.6 filter has a density of 0.6, needs an exposure increase of 2 stops, and may be labelled ND×2. Such a filter transmits 25% of the light falling on it and may thus be labelled ND25.

The table above lists commonly available densities. You can get others either to special order, or by combining existing filters. Their densities simply add together, multiplying their filter factors. Naturally the number of stops exposure increase can be simply added together as they can for any other filters (see page 86). Like any other filter, neutral density filters deviate slightly from their specifications. They are quite accurate enough for normal photographic purposes, but must be tested under working conditions if they are to be used for critical work.

Using wider lens apertures

Fit a neutral density filter on your camera lens and you can use a wider than normal aperture at a chosen shutter speed.

On a bright day, when using even quite slow films, most cameras are restricted to moderately small apertures. A 100 ASA film needs an aperture of only $f8$ at $\frac{1}{500}$ second in bright sun. This may be too small to give adequate differential focus. Using a neutral density filter allows you to open up the lens without altering anything else. A ND1.5 has an exposure factor of $32\times$ or about 5 stops. Fit this over your lens, and you can open up to $f1.4$ at $\frac{1}{500}$ (or $f2$ at $\frac{1}{250}$). A paler filter allows you to make smaller alterations, to give you exactly the degree of differential focus that you need.

Adjusting movie exposures

Being able to use a larger lens aperture is particularly important with movie cameras. On most amateur cameras, the exposure time is fixed by the framing rate. The commonly used 18 fps give an exposure of between $\frac{1}{25}$ and $\frac{1}{40}$ sec depending on shutter construction. The short focus lenses used in 8 mm cameras (standard about 13 mm) cannot be stopped down below about $f16$ without creating mechanical and optical problems. Although this is a just acceptably small aperture with slow films (25–32 ASA), it gives considerable over-exposure with faster films.

Faster movie films are now widely available, so camera manufacturers incorporate a neutral density filter. As the lens aperture is adjusted (either manually or automatically) a normal physical aperture is supplemented by a filter at small settings. This in no way affects the camera operation, as the aperture scale is calibrated as if the lens were simply being stopped down in the normal way.

If you have an older camera with manual lens setting, you can use high speed films in bright conditions if you fit a neutral density filter on the lens. A filter of 0.9 density has a factor of $8\times$, reducing light transmission by three stops. This should be adequate for the fastest currently available films in almost any camera. With the filter in position, use an aperture setting three stops larger (i.e. three f-numbers smaller) than your meter indicates. Alternatively, if you cannot alter the speed setting of a built-in meter, use a $3\times$ filter on the lens for 200 ASA (or 160) film. The meter setting for 25 ASA film then gives cor-

rect exposure – *as long as the meter does not read through the filter.* This also works with an automatic camera – again provided the meter does not read through the lens (and the camera is fixed on a 25 ASA film speed). You can thus take pictures even if you can't get your normal slow film; but removing the neutral density filter will result in over-exposure even in dull conditions. So, if you have to, use fast film and a neutral density filter, but use it just like you use slow films without the filter. If your automatic camera has TTL metering, you can only use film of speeds you can set on the meter. Neutral density filters will make no difference.

Colours with integral neutral density

A number of coloured filters, commonly used for motion picture work, are manufactured with neutral density incorporated. These filters have a dual function. They correct colour balance or tone rendering, and allow a wider lens aperture to be used.

The filters are distinguished by a letter 'N' in their number. Thus 8N5 is the familiar yellow 'cloud filter' (see page 98) with added absorption of 0.5 throughout the spectrum. It acts just like an 8 together with an ND0.5 and thus has a filter factor of $\times 6$ (2×3) and needs an exposure increase of 2 $^2/_3$ stops. Photographically, it can be regarded as an 8.

The filters for using both types of tungsten light film in daylight are available with several different neutral densities added. Although 85B is the normal recommendation for tungsten light movie films exposed in daylight, 85 filters are also supplied with added neutral density. Many studios use them in preference to the slightly more coloured 85Bs.

Using longer shutter speeds

The other variable in exposure control is the shutter speed. In still photography, this too can be adjusted with filters. Keeping the same aperture, you simply multiply the speed by the exposure factor to give the same exposure through a density filter.

A comparatively pale filter can give you a suitable speed for blurring motion. On a bright day, a 100 ASA film needs about $^1/_{125}$ second at *f*16. Use an ND0.9 and you can give $^1/_{15}$ at *f*16 instead. Adjusting the

aperture now gives you plenty of choice of suitable speeds for panning, or for most other types of picture showing movement.

On the other hand, very dense filters allow you to take pictures over a period of several hours. Combining two ND4.0 filters gives a theoretical exposure of about 27 hours at $f16$ with 100 ASA film in bright sun. Because the film will undoubtedly exhibit reciprocity law failure over such a period, 24 hours at $f8$ might be more suitable. Since there are few locations where the sun shines brightly for 24 hours on end, that could be divided into two 12 hour sessions, or altered again to 12 hours at $f5.6$.

Such an exercise is not an absolute absurdity. You could use it, for example, to record the path of the sun across the sky (using a fisheye lens). Another use (maybe needing not quite such a long time) is in picturing busy places as empty. If you set up your camera to picture a scene; use suitable filters and aperture for several hours' exposure; open the shutter and even the quite frequent passage of pedestians or vehicles will not show in the film.

Naturally, a continuous flow of traffic will come out as a blur. However, the normal mid-morning flow of people round an art gallery can probably be lost altogether. Do put the lens cap on, though, if anyone stands still in the field of view.

Because the effects of reciprocity law failure are unpredictable, really long exposures with colour films must be the subject of testing in the circumstances.

Electronic flash

As the duration of electronic flash is short, exposure cannot normally be affected by shutter speeds. The combination of flash unit and a particular film may give over-exposure at short flash-to-subject distances. A ring-flash or similar source cannot be moved further from the subject than the camera. The only way to decrease the light reaching the film is to use a neutral density filter. Simply calculate the required aperture from the flash distance and guide number. Decide how many stops the exposure must be decreased by, and use a suitable neutral density filter. The filter may be fitted over the flash or over the camera lens. If it is fitted over both, it decreases the exposure by twice as many stops.

For example, suppose you want to use a flash with a guide number of 90 (feet, for the film you are using) 2 ft from your subject. The

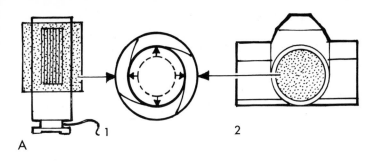

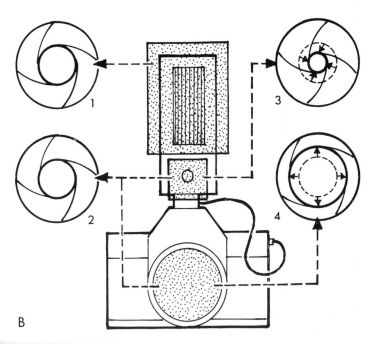

Flash and neutral density filters. A, With a manual gun, a filter on the flash tube or camera lets you use a larger aperture. B, With a computer gun, the possibilities are greater: 1, Over the tube, you get a longer duration flash but the same exposure; 2, over the sensor *and* lens you also get a longer duration flash; 3, Over the sensor alone, you get a longer duration flash and must use a smaller aperture to compensate. 4, Over the lens alone, you use a larger aperture just like normal flash.

calculated aperture is $f45$ $^{90}/_2$. If your lens will only stop down to $f22$, you must reduce the exposure by at least 2 stops. For this you need an ND0.6 filter either on your camera, *or* on your flashgun. Alternatively, you could use ND0.3 filters over your flashgun *and* over your lens. Either way you reduce the light reaching the film by 2 stops, and get correct exposure with the lens set to $f22$.

Computer flashguns have a sensing mechanism which cuts off the flash of light when the subject has been illuminated to a measured amount. If the camera controls are correctly set, within the range of the unit the exposure is satisfactory whatever the flash-to-subject distance (as long as the sensor is kept with the the camera). Few guns have a remote sensor, so the flash must usually be mounted on or near the camera. For close-ups, this gives extremely short exposures, which lead to reciprocity law failure problems with some colour films (see page 85). The best way round this problem is to fit a neutral density filter over the flash tube *but not over the sensor*. The filter reduces the intensity of the flash and the sensor mechanism does not cut off the light so quickly.

Suppose the unit has a maximum guide number of 90 (this is what it will give on its 'manual' setting) with the film you are using, gives its full output in $^1/_{1000}$ second, and requires a lens aperture of $f8$ for automatic operation. If you are photographing from 2 ft, the full ($^1/_{1000}$) flash needs an aperture of $f45$. The sensor must therefore reduce the flash output by 5 stops (f 45 − $f8$); so it cuts off the light after about $^1/_{32} \times ^1/_{1000}$ second, or $^1/_{32000}$ second. This short exposure can lead to problems. If you use a ND1.2 (16×) filter over the flash head, the full flash needs an aperture of $f11$; the sensor thus only cuts the flash off at about $^1/_{2000}$ second, which should not cause any problems.

If you know the maximum guide number and flash duration of your unit, you can alter the flash duration for close-ups simply by choosing suitable neutral density filters to use over the flash tube. When you have calculated the filter-less flash time for your working distance, you simply multiply it by the factor for the neutral density filter you put over the tube.

Naturally, you can use neutral density filters over the camera lens if you want a larger aperture with a computer gun. If, for example, your flashgun needs to be used at $f8$ but you want to shoot at $f2.8$, you can use a ND0.9 filter over the camera lens. The flash is then measured by the sensor as if the lens aperture were $f8$ but the filter over the lens absorbs seven-eighths of the light reflected from the subject.

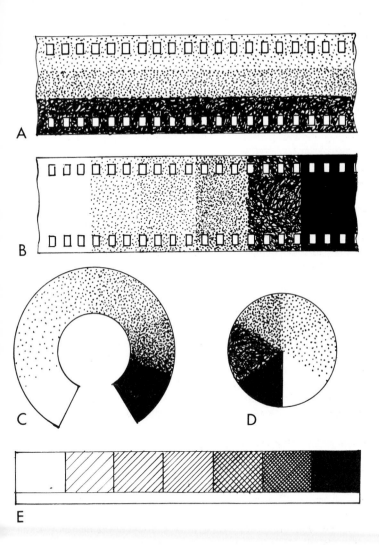

Neutral density wedges. A B, You can make your own wedges for enlarging exposure determination. C D, Alternatively you can buy all types of wedge. E, A grey scale can be photographed to give a suitable wedge.

Filtering windows

A major problem of interior scenes in daylight is that the windows are usually much too brightly lit. Even with strong flash to light the interior, the windows may 'burn out' in your picture. On a bright day you cannot hope to match the exterior brightness, so you must reduce it. Studio type filters are made in neutral density for this purpose.

Neutral density wedges

Neutral density is manufactured also in graduated or step wedges. These, and other types of variable density, are used for light measurement. They are commonly used for exposure measurement in printing. A number are sold as printing exposure calculators.

You can make yourself a suitable step wedge from sheet film, or from a short strip of 35 mm film. Use an enlarger, or similar light source, set to a small aperture for fogging the film. Process it in the normal way.

Determine — on separate piece of the same film — how much exposure you need to just fog the whole film to solid black. Now cover exposure you need to just fog the whole film to solid black. Now cover up the very end of your unexposed strip, then masking it with a card, expose the rest progressively along its length $1/30, 1/15, 1/8, 1/4, 1/2$ and the full blackening time.

When you have processed this, it should be a series of 7 different tones including unexposed film and black.

When printing from negatives, you can make test strips by exposing on to a piece of paper with the step wedge lying on it. After you have selected your enlargment, use a wide enlarger aperture and a measured time. After a few tests, you will be able to tell by looking at the range of densities by how much to stop down your lens, or shorten your exposure time to give you a correctly exposed print.

When you are adept at using a step-wedge, you may find it more convenient to make one with the steps running along the film. Use three suitable exposures — say $1/2, 1/4$, and $1/8$ of the full exposure. You can than make test-strips covering a range of features from your negative. Much more complex coloured step-wedges are used for colour exposure calculation.

Polarizing
Filters

Light travels in straight lines from its source, and has a vibratory motion. The vibrations are across the direction of travel but they may be in any plane. Thus light from the sun, or other light source, consists of a random mixture of rays vibrating in all planes along its direction of travel.

Sometimes the vibrations can be restricted to one plane. The light is then said to be *plane polarized.* The direction of vibration is the plane of polarization. Plane polarized light may be produced by special filters, or by reflection from non-metal surfaces. Some transparent substances rotate the plane of polarization. Others cause it to take up a sort of helical motion. It is then called *circularly polarized* light. For most photographic purposes, you will be interested only in plane polarized light. It is generally just called polarized, and photographic polarizing filters are normally plane polarizers.

Natural sources of polarized light

No natural light source directly produces polarized light, but light from many sources may be polarized by reflection. This happens most strongly in sparkling reflections from shiny surfaces. Most non-metallic substances can polarize light as they reflect it. The polarizing effect is related to the angle of reflection. (To be specific, the maximum polarization occurs when the tangent of the angle of incidence – which is the same as the angle of reflection – equals the refractive index of the reflector.) In most cases maximum polarization occurs when you are looking at the surface from an angle of about $30 - 40°$.

A special case of this type of polarization is found with partially reflecting surfaces such as those used as beam-splitters. The reflected rays and transmitted rays are at least partially polarized in different planes. Another major source of polarized light is the sky. As the blue light is reflected and dispersed by atmospheric particles, it becomes polarized. The effect is least just beside the sun, and diametrically opposite it. The greatest polarization occurs in the area of the sky at right angles to the direction of the sun.

Polarizing materials

Light may also be plane polarized as it passes through certain minerals. These substances transmit light polarized in a particular

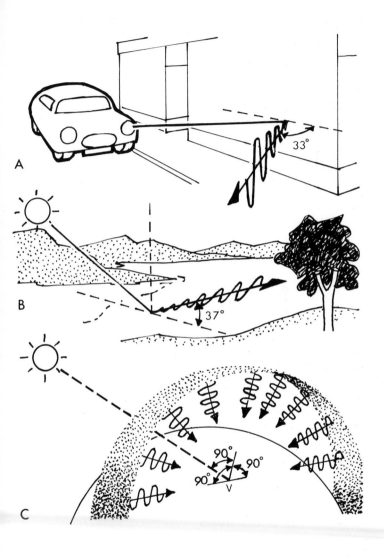

Natural sources of polarized light. A, Light reflected at about 33° from glass is polarized. B, So is light reflected at about 37° from water. C, A band of skylight is strongly polarized.

plane. They absorb light polarized at right angles. Filter manufacturers produce sheets of polarizing screen (or filter) materials, with a uniform polarizing effect overall.

Such a filter thus transforms normal light into plane polarized light. It also restricts the passage of already polarized light *unless* it is polarized in the same plane. Thus, a polarizer rotated in a polarized light source will appear alternately pale and dark: pale when its polarizing effect is parallel to the plane of polarization of the light, and dark when it is at right angles.

When the incident light is polarized in a plane neither exactly parallel to the filter plane, nor exactly across it, the filter transmits some of the light. The closer the plane of polarization of the incident light comes to that of the filter, the more light it transmits.

The most common use of polarizing material is in sunglasses. The lenses are set to transmit only vertically-polarized light. Most disturbing glare comes from reflections from the earth's surface. These tend to be horizontally polarized and thus are eliminated by the sunglasses.

'Depolarizing' polarized light

If polarized light is scattered, it loses its polarization. The scattering is equally effective whether it is by reflection from a matt surface, or transmission through a translucent substance. Naturally, partial scattering leads to partial depolarization. For example, although flashed opal glass diffusers are strong depolarizers, ordinary ground glass has only a slight effect.

There is no 'depolarizing filter'. Polarizers act by transmitting light rays already vibrating in one plane. If the light falling on them is already polarized, they transmit it only if they are orientated correctly. If the planes of polarization cross, the filter then absorbs all the polarized light.

Polarizing filters in natural light

If you use a polarizing filter over your camera lens, you can control polarized light reaching the film. Light polarized at right angles to the filter's plane of polarisation is totally absorbed.

Careful camera placing can use this phenomenon to suppress reflec-

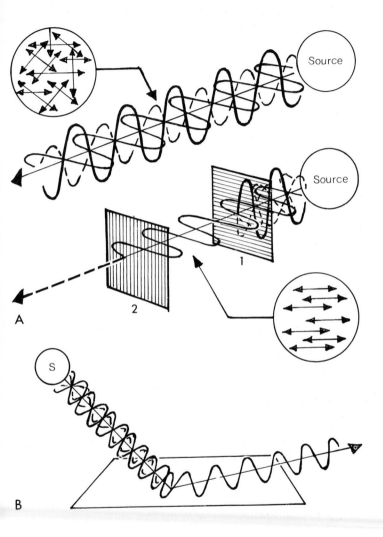

Polarized light. A, Light from most sources vibrates randomly: 1, only vibration in one plane is left after it passes through a polarizing filter; 2, a differently oriented filter absorbs this, letting no light through. B, Reflected light is polarized in a plane at right angles to the direction of reflection.

tion. For example, you can take pictures through glass windows (or picture mounts) if you select exactly the right angle between your light source and the camera. Similarly, you may be able to picture fish through the otherwise glistening suface of a pond. To be suppressed at all, reflections must leave the surface with an angle between about 20° and 70°.

A more subtle use is found when taking colour pictures of shiny subjects, such as wet grass, which reflect directly a certain amount of the light falling on them. This dilutes their colour, making it appear more pastel. Some of this directly reflected light is polarized, and can be selectively reduced with a polarizing filter.

Blue skies are polarized

As the light from certain parts of the sky is strongly polarized, it can be reduced with a polarizing filter. You may use this effect to increase cloud contrast in black and white pictures, but will get a more even sky darkening with coloured filters (see page 100). A polarizing filter is, however, the only way that you can selectively darken the sky in a colour picture without altering other colours. The darkening effect is strongest when the sun is directly to one side of you; and it is greater the higher you look from the horizon.

Filter orientation

Whatever effect you are looking for, you should view the subject through the filter; rotate it until you get the strongest suppression of unwanted reflections (or colour dilution), and use the filter in this orientation on your camera. Of course, if you want a less strong effect, you can rotate the filter one way or the other until it is just right.

If you are using a single-lens reflex, naturally you can look through the viewfinder with the filter mounted on the lens. With a twin-lens reflex, you can put the filter on the viewing lens; select the orientation you need: then – without further rotating the filter – fit it over the picture-taking lens. Otherwise, you must determine how the filter should be used before you fit it to the camera. Make quite sure that you don't turn it round *at all* while fitting it. Strong suppression effects are only possible within a few degrees of the optimum angle.

Some filters are mounted with a handle for ease of rotation. This han-

dle normally runs parallel to the plane of polarization. In some cases it may have a small filter in the end. You can mount the main filter on the lens of a non-reflex camera; view the subject through the small filter as you rotate the whole filter in its mount. The effect of the main filter duplicates that of the small one. Thus – within limits – you can set your filter orientation visually.

Polarized light sources

A sheet of polarizing material fitted in front of a studio lamp or flash-gun gives a polarized light source. A polarizing filter appropriately orientated on your camera lens can prevent light from such a source reaching the film. It can also block such polarised light that is specularly reflected to your camera, whereas any light reflected from a matt surface is depolarized, and thus not absorbed (completely) by the camera filter. You can thus light any subject likely to cause reflection problems with polarised light and absorb reflected light with a filter on the camera – regardless of shooting angle.

This allows you very accurate control over reflections. By careful choice of filter orientation, you can get just the amount you want. You can, of course, use a number of polarized sources. Normally, they all have to be polarized in the same plane if you are to be able to control them all with your single camera filter. In most studio set-ups, you will need only to fit a polarizing filter over one light which is causing troublesome flare.

One particular note of caution: polarizers are permanently damaged by excessive heat. Don't put your filters in normal filter holders on studio lamps. Keep them well in front, and only put them in place at the last minute. Even the modelling lights in studio flash units may be enough to damage the filters.

Optical activity and birefringence

Some transparent substances rotate the plane of vibration of light rays. Under every-day conditions, this property (called optical activity) goes unnoticed. However, if an optically active substance is placed between two polarizers, the rotation can be observed.

A *birefringent* substance splits up incident plane polarized light into two components polarized at right angles to each other. The sub-

stance has a different refractive index for the two components.

Normally, two crossed polarizers transmit no light. If a substance or object between them rotates the plane of light polarized by the first polarizer, the light then passes through the second. Attractive abstract pictures can be made with suitable arrangements of transparent plastic objects between polarizers. The degree of rotation varies with the wavelength of the light. So such set-ups can produce strong colours on colour films.

When a birefringent substance is placed between crossed polarizers, the second polarizer lets through part of both the emergent rays. These parts are polarized in the same plane, and come from the same light source. Thus they can interfere with each other to produce colour and intensity variations — just like those you see from an oil film floating on a puddle.

Stress analysis

A particular use for birefringence stems from the fact that the light-splitting effect of some plastics is determined by stresses within them. Engineers make (flat) models of gears, sections through buildings, and so on. They arrange for scale loadings, and place the models between crossed polarizers. The areas of stress show up as areas of greater (or smaller) light transmission. As the rotation varies with wavelength and emergent beams interfere, colour photographs taken with white light reveal the stress patterns as bands of colour.

Crossed polarizers

A simpler use of crossed polarizers is as a variable neutral density filter. Two filters with their polarizing planes parallel transmit some 200,000 times the light they transmit with the planes crossed at 90°. Faders are constructed by mounting two similar filters together, allowing one to be rotated while the other is fixed to a lens. Rotating the filter gives an infinite variety of neutral densities between the limits.

Such variable filters can be used as progressive faders for movie cameras. On simple cameras they can be used to fade a scene out of and into black. (Even this is complicated on fully automatic cameras with through-the-lens metering.) On more sophisticated cameras,

Steroscopic colour projection. Two images, polarized at right angles are seen separately by the two eyes, giving an impression of depth. 1, Metallised screen. 2, Left eye image. 3, Right eye image. 4, Horizontal polarizer. 5, Polarized glasses. 6, Vertical polarizer.

they may be built in to allow you to make dissolves from one scene to another. Unfortunately, the fading is not linearly related to the rotation. Almost all occurs within the last few degrees up to the fully crossed position. This makes progressive fades difficult.

Stereoscopic projection

We see things with two eyes separated by a short distance. The slight differences between the two images give us a strong impression of depth. Seeing with two eyes (each giving a slightly different picture) is called *stereoscopy.* The impression can be recreated if two photographs taken with a suitable separation are seen separately by our two eyes.

The first stereoscopes used a system of lenses and barriers so that the view of each eye was physically restricted to the required picture. Later, pictures were produced in two complementary colours, and vision restricted with similarly coloured filters. This system allowed the images to be projected for an audience wearing spectacles with appropriate filters, but did not allow colour photography to be used.

If the two images are polarized (one horizontally and one vertically) they can be seen selectively through spectacles polarized in the same way. The two images – which can be in full colour – are projected on to one screen from two projectors. The projectors are fitted with polarizers so orientated that the audience (provided with suitable polarizing spectacles) see the right-hand image with their right eyes, and the left one with their left eyes. The projector screen must be metallized, so that the polarization is maintained as the image is reflected to the audience.

Exposure with a polarizer on the camera

Polarizing filters have a factor of about 2.5×. So increasing exposure by about 1 ⅓ stops gives the correct density. For normal scenes, it does not matter how the filter is orientated, the correct exposure will be the same. The filter's selective absorption of the highlights just prevents them from burning out. If the scene contains a strong light source, a reflected light reading may suggest too little exposure for the rest of the scene. Naturally, the scene will be under-exposed if this reading is followed directly, or modified for use with a filter.

If, by chance, the strong light is polarized you may get a better reflected light reading of the whole scene if you meter through a suitably orientated polarizing filter. (This gives you the required exposure through the filter.) Cameras which meter through the lens can give aberrant readings through a polarizing filter. Some use a system whereby the meter cell reads light 'bled off' from the main light-beam by a beam-splitter. If the beam-splitter polarizes the light, it may obstruct transmission of all (or most) of the light polarized in a certain direction. Of course, this can lead to over-exposure recommendations.

If you use a through-the-lens exposure meter, you can test whether a polarizing filter affects it. On an overcast day, set up your camera to meter from a normal subject. Fit a polarizer over the lens: and observe the meter read-out while you rotate the filter. If the meter indicates exactly the same exposure in all orientations, you can trust the readings. If the needle moves at all as a result of the rotation, do not meter through a polarizing filter. Take your readings first, and increase your exposure by $1\frac{1}{3}$ stops to compensate for the filter.

A circularly polarizing filter is available for Leica cameras. This has the same effect on the subject as a linear polarizer, but does not produce plane polarized light. It allows accurate metering even though the meter cell is fed from a beam splitter.

Circularly polarized light

Circular polarization produces light which does not vibrate in a single plane. It vibrates in spirals (helices). These may be either left-handed or right-handed. Circularly polarized light can pass through a normal plane polarizer, but may be stopped by a circular polarizer of the opposite rotation. A circular polarizer consists of a linear polarizer and a special 'quarter wave retardation plate'. Light striking the linear polarizer first is selectively absorbed exactly as if the plate were not there. That which is transmitted reaches the quarter wave retardation plate as plane polarized light. The plate (suitably orientated) turns the plane polarized light into circularly polarized light.

Circular polarizers are used over the face of shiny (internally lit) instruments or television display tubes. Any light from outside is polarized as it passes through the filter. The handedness is reversed as the light is reflected from the dial. Reflections are therefore absorbed by the filter and do not obstruct the information.

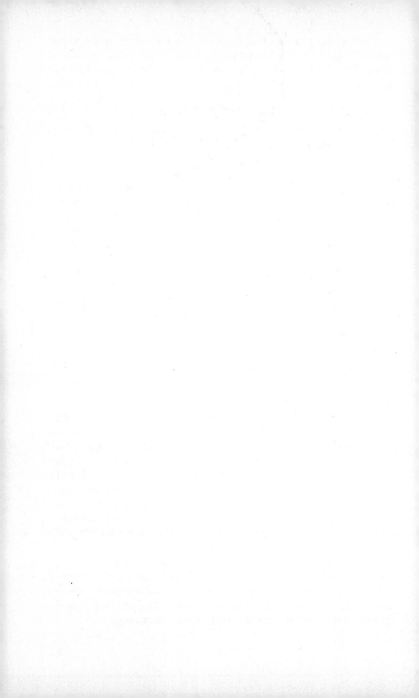

Beyond
the Visible
Spectrum

Light is only a small part of the electromagnetic spectrum (see page 219). Unlike our eyes, photographic materials are not restricted to light. The light-sensitive silver halides are also naturally sensitive to shorter wavelengths: ultra-violet (UV), X-rays, gamma rays and cosmic rays. The natural absorption of glass lenses, and the gelatin used in emulsions restricts normal photography to the near UV – down to about 350 nm. Materials may also be sensitized to long wavelengths in the infra-red (IR). Storage problems occur with materials sensitized to the far IR. So for practical purposes, you are limited to radiations up to about 900 nm.

With a suitable choice of filters, you can restrict your photography to any part of the radiation between about 350 nm and 900 nm. Naturally, you will want to record invisible radiation only if this will show you something that you can't normally picture.

For example, visually white substances can vary in their UV absorption, black substances in their IR reflectance. They thus come out different tones on the UV or IR picture, although they photograph identically with normal light photography. A special use of IR photography is in recording subjects in the dark without their knowledge.

You may photograph beyond the visible spectrum for technical purposes, or just to make an attractive picture.

UV photography

Normal panchromatic films are suitable, but to restrict your photography to UV radiation, you must make sure that no light reaches them. The simplest way to do this is to fit a visually opaque filter to the camera. UV transmitting material is known as Wood's glass. Several manufacturers supply filters for this purpose – for example, the Wratten 18B, or the denser 18A.

Such a filter transmits UV, and absorbs visible radiation. Thus, you can make your UV record in lighted surroundings. However, the filter transmits in the infra-red region. So you must take precautions to prevent such radiation reaching the film. A heat-absorbing glass (see page 201) is suitable for this purpose.

Most normal photographic light sources emit UV. They are suitable for recording static subjects, but need exposures too long for moving ones. A special UV source, such as a 'sun lamp', a laboratory UV lamp, or a mercury vapour lamp, gives much more radiation, but must

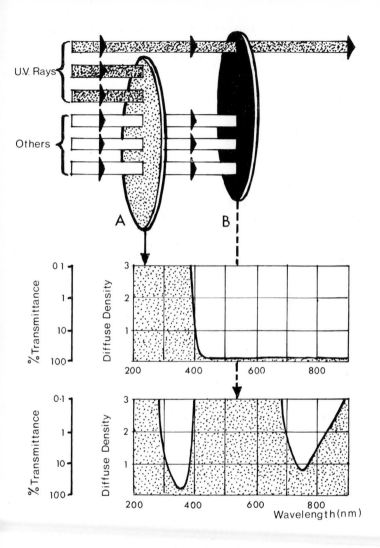

Ultra-violet filters. A, UV-absorbing filters let light through. They are used to reduce haze and blue casts. B, UV-transmitting filters absorb light. They are used only in UV photography under controlled conditions.

be treated with care. Long exposure can cause serious skin burns. If you use a UV source turn it on only for the exposure, wear UV absorbing glasses, and *never* look directly at the lamp.

You can restrict the output of your light-source to UV radiation by fitting a Wood's glass filter. Naturally, if you don't fit a filter on your camera lens, you must use the technique in the dark. To be sure of restricting your record to the UV, you can use a filter both on your radiation source and on your camera lens.

UV fluorescence photography

Many substances fluoresce visibly in UV radiation. Some of the UV is converted into longer wavelengths by the fluorescent substance. You can record this either in monochrome or in colour.

To record fluorescence, you must have a totally darkened chamber. As exposures can be extremely long, the normally unimportant light leaks commonly seen in a domestic darkroom can fog the film. You must use a UV source fitted with a visually opaque filter. This ensures that no light reaches the film from the UV source. As well as this, you must have a UV absorbing filter on your camera lens. This confines the record to visible (and IR) radiation. Without this, the film would record the subject by reflected UV. A normal UV or haze filter (IA) is not suitable because it transmits some UV. A 2B or 2E is required.

A record of nothing but the fluorescence is difficult to relate to your subject. To get round this, you can give a small secondary exposure to light. This should be at a level to underexpose the picture by two or three stops.

This is one form of UV photography where colour film can be useful. Fluorescence can be of many colours, and you can get very attractive pictures. However, the extremely long exposures usually needed cause problems. Because of reciprocity law failure (see page 85), you cannot be sure of the colours in the result. Normally, high speed daylight type materials are best for fluorescence photography.

Exposure

For UV pictures the exposure can be determined only by trial and error. Normal exposure meters are not suitable. With an ordinary light source you can make a test film using 2, 4 and 6 stops more than you

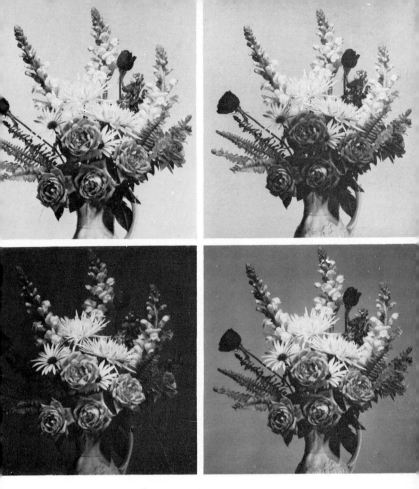

Top left: Changing the contrasts. With pale yellow filter, a panchromatic film produces a picture in more-or-less the same tones as the original coloured subject (see p. 65).

Top right: A green filter darkens the reds and pinks, leaving other colours more-or-less the same tone. So the contrast between the red and yellow flowers is heightened.

Bottom left: A red filter so darking the background that green leaves and purple flowers are lost against it. The pink roses are more-or-less unaffected, and the yellow and white blooms come out very light.

Bottom right: A stronger yellow filter has the same sort of effect but is much less pronounced. Whites and yellows are indistinguishable – *Pictures by Hoya.*

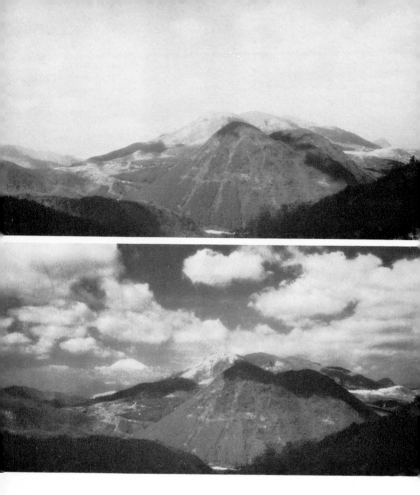

Although yellow filters are normally used, other colours may sometimes be better for bringing out the clouds. Here an orange filter produces an interesting sky (bottom) without making too much difference to the foreground – *Hoya*.

A red filter darkens the sky considerably (bottom), it also darkens the sea because it too is blue – *Hoya*.

P132–3: A rather flared but quite ordinary into-the-sun picture (left) is made more dramatic with a strong red filter – *BDB*.

Page 134: A fog filter can turn a sunny day to winter. It works on transparency films too – *BDB*.

Page 135: The right degree of diffusion lends an almost luminous quality to a simple portrait – *Kodak*.

Infra-red sensitive film with a suitable filter turns a forest landscape into an almost negative scene. Wood's effect results in all the leaves coming out pale, and to compensate, most of the rest is considerably darker – *Kodak*.

would with a normal light record. Fluorescence is at such low intensities that no ordinary meter is able to measure the light.

Focusing

Naturally in a darkened set-up, you must focus before turning out the lights. Visual focus on a screen is biased toward yellow light. UV comes to a focus some way in front of this. If possible, focus with blue or violet light—but *not* with the output of a UV source. Because of the possiblility of accidents, it is wiser not to use a camera with a separate viewfinder, so that you cannot look through it during exposure.

Common uses of UV photography

UV photography can tell you more about the character of a surface, and what lies just below it. UV is not particularly penetrating radiation, and does not reveal deep features. Thus one important application is in dermatology – the study of the skin. A number of diseases alter the UV reflection of the skin pigments and are revealed by photographs.

Faded and even erased inks can be seen more clearly in some UV photographs. So UV photography is used in archaeological restoration, and in the investigation of suspected forgeries.

UV fluorescence photography is, however, a more striking technique. Many thousands of substances fluoresce under UV irradiation (some also fluoresce under other conditions).

One UV fluorescent substance is the cellulose from which most papers are made. This fluorescence can be altered by erasing fluids: thus the technique is again important in investigating questioned documents.

Some of the most attractive fluorescence is shown by minerals. With a little experimenting, you should be able to produce attractive abstract colour pictures from arrangements of mineral samples. Some samples contain more than one fluorescent mineral, so you can get intermingling colours.

Technologists make fluorescence photographs for less frivolous purposes. Mineralogists use them to analyse samples. Biologists use them to identify minute animals from their natural fluorescence. They also use a number of fluorescent stains, especially in microscopy.

Comparing UV fluorescent pictures with unfiltered ones can yield important information.

Black-and-white IR photography

Normal panchromatic films are not suitable for taking IR pictures. Special IR-sensitive black-and-white and colour films are used. Colour films are discussed on page 144.

IR-sensitive films are also sensitive to light. They record IR alone only if they are used with a visually opaque filter, or in total darkness. For most purposes, however, it is easier to use a deep red filter. This confines the picture to the far red and the IR.

Normal photographic light sources radiate IR strongly. Alternatively, strong heat sources can be used. The wavelength limit for readily available IR-sensitive film prevents the use of sources below about 250° C (480° F). Thus you need a heater, not just something warm. In fact, sources below about 300° C (575° F) require very long exposures.

With normal light sources, you must restrict the radiation to IR (or IR and red light) with a filter. You can put the filter on the light source, or over the camera lens. Suitable visually opaque filters are readily available – for example the 88A. Any strong red filter – such as a 25 – is suitable if you do not need to confine your exposure entirely to IR. Of course, if you are using an IR source (either natural or filtered) without a camera filter, you must have no light from other sources.

In the dark, you can use a conventional light source covered with a filter. Filter bags are particularly suitable for this purpose. They are designed to be used with a flash-gun – either bulb or electronic. You can, however, use normal optical grade gelatin filters; or non-photographic filters. In pitch darkness, the flash shows a dull red. In low light conditions it is only seen by someone looking directly at the light unit. To be quite sure that it is not seen, you can use bounced flash. Naturally, when you are using IR photography solely to conceal the lighting, you do not need any filter on the camera.

Exposure

IR materials are often given exposure meter settings which take account of the filter used. These settings are for use with a normal light

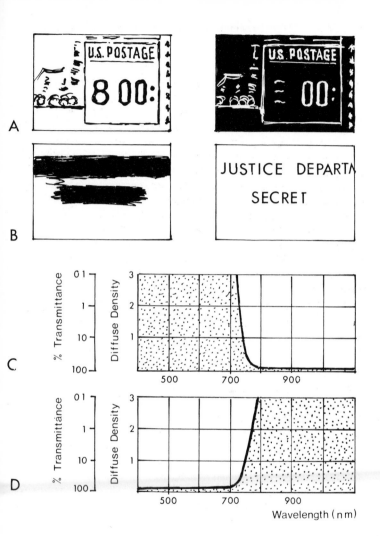

Infra-red photography. A, Differences in IR reflection can show up fraudulent alterations. B, They can also reveal some overscored information. C, IR-transmitting filters absorb light. D, IR-absorbing filters transmit light.

RECOMMENDED FILM SPEED SETTINGS FOR KODAK HIGH SPEED INFRA-RED FILM

| Filter Used | Meter Settings (ASA) | |
	Daylight	Tungsten Light
None	200	80
Red	125	50
Opaque (88A)	64	25

meter. The IR itself is not measured. Light sources vary in their IR content, so meter settings must be related to the light source, and special tests made when using unknown sources.

One special point to watch is that 35 mm cassettes are not IR-proof. So you must open the packing and load your camera in total darkness.

Viewing and Focusing

You cannot focus a screen image (e.g. on a SLR camera) with a visually opaque filter in use. Unless you can focus before you fit the filter, you need a separate viewfinder. Rangefinder cameras are particularly suitable for this purpose.

However, IR is not brought to a sharp focus in exactly the same plane as visible light. With a standard lens used at apertures larger than about f5.6, you must shift from the visual focus point if you want a sharp IR picture. You must always shift the focus on a long focus lens; an IR image may not be brought to a sharp focus even at f22 on a visually focused 300 mm lens. You can get closer to the IR focus point if you focus your screen image through a deep red filter.

Most modern lenses have an IR focusing mark against which you can set the measured distance. If you have focused visually on a screen or with a range finder, move the setting from the main index to the IR index. If there is no indication of the shift on your lens, look at the marked lens of similar focal length, and estimate where the mark might be.

Before using a wide aperture (which is necessary with most IR sources) when your focus is important; make a series of tests. They should tell you whether your IR mark is in the right place, and whether you can judge your distances in low light.

IR for effects

Used outdoors, IR film and a red or visually opaque filter gives you pictures like those taken on panchromatic film with a red filter (see page 95) only more so. Skies are even more dramatic, seas sparkle, and haze vanishes.

But one unexpected thing happens: leaves turn white. Living plant tissues reflect IR strongly. They become the lightest parts of a landscape. This phenomenon—sometimes called the Wood effect—is so marked when you use a visually opaque filter that it can spoil the picture.

As the haze penetration is considerable, you can use IR film and filters to take clear pictures on hazy days. Even mist is not entirely opaque to IR, and you can penetrate it further than you can see.

If there is not too much foliage, and the sky is free from clouds, pictures taken on a sunny day may appear to be moonlit. The contrast of the IR films tends to be high, and you may need to use soft paper to get a real moonlight look. Slight under-exposure of the negative can also help. You may find that a red filter produces a more 'natural' result than a visually opaque one.

Photography in the dark

There are two main uses for unseen photography: surveillance and nature. Surveillance techniques are used for military and civil information gathering. Banks and other areas susceptible to crime can be fitted with automatic IR cameras and lighting. These may take pictures at predetermined intervals, or be set to shoot if intruders are detected mechanically.

For the natural historian, IR is invaluable. Many mammals are nocturnal in habit. They are disturbed by any artificial lighting. So if their natural behaviour is to be observed, it must be by moonlight or by radiations they cannot see. The only exception is on a stormy night, when a diffused or bounced flash-gun be 'mistaken' for lightning. Most mammals and birds are insensitive to IR – and indeed many are also unaware of red light. Thus, you can use a flashgun or movie light fitted with an IR filter. Naturally, you must also ensure that they are unaware of your presence. In many cases, you will get better results if you set up your equipment by runs or nests, fit an automatic trigger device and go away.

in popular fiction, forensic scientists can take photographs of almost any scrap of material and come out with a picture covered in writing. Much of this legend comes from IR photography. Many old, worn or obliterated inscriptions are quite clear when photographed by IR. With quite simple equipment – a camera and filters – you can make suitable IR pictures to reveal something of what lies below the surface of documents and pictures.

For example, if a pigment type printers' ink is covered up with a dye type writing ink it can be totally illegible. In an IR photograph the IR absorption of the pigment may be distinguished from the reflection of the dyes. This may be particularly spectacular if the printed material has been fraudulently altered in visually identical ink.

A major triumph for IR photography came in the deciphering of the Dead Sea scrolls. Much of the writings were indecipherable on the blackened 2000 year old parchments. Yet with simple IR reflectance photography, they were clearly and easily read.

Another major field is in the evaluation of paintings. IR photography may distinguish new paints from old, thus revealing restorations. As IR pictures include what is below surface, the sketching, blocking in, corrections, and other facets of the artist's method can be seen. In some cases IR photographs have shown that famous artists painted over their earlier works. The science of picture restoring has reached such a level now that one or two of the pictures thus revealed have been separated and seen for the first time for hundreds of years.

One important technique in revealing features below the surface is to suppress the surface features. You make two negatives: one on IR film (with a red or opaque filter), and one on normal film with a red filter. Make a same size positive mask from the normal negative and combine it with the IR negative. This cancels out the tones equivalently recorded by light and IR. Thus a print made from the sandwich shows only the differences between IR and light reflection. The strong IR reflection of living plant tissues allows you to distinguish them from similarly toned inanimate objects. This was an important military use of IR photography – camouflaged objects hidden to view were revealed in the IR picture. However, now most military camouflage materials are treated to reflect IR.

Perhaps more important, this phenomenon can be used to distinguish dead or diseased trees and plants in aerial photographs. As IR reflection is related to plant growth rates, IR pictures can show the in-

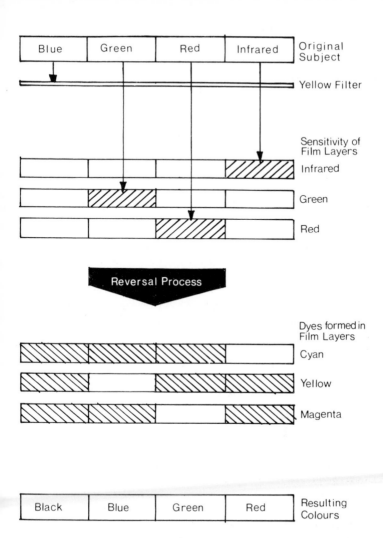

Kodak Ektachrome Infra-Red Film. The three emulsion layers are sensitive to green, red and infra-red. A yellow filters absorbs blue light from the subject. The layers become coloured yellow, magenta and cyan like a normal reversal flm (see p. 49).

fluences of nutrition treatments, or pest infections. Subsoil de-rangements also effect plant growth rates. Thus IR photographs are of particular interest to the archaeologist. Most permanent settle-ments have involved digging. The diggings can still be seen in an IR aerial photograph after thousands of years.

Coloured IR photography

One 'false-colour' IR film is available: Kodak Ektachrome Infra-red. This film works like a normal colour film (see page 48), except that the sensitivities of the three dye-forming layers are moved 'one step' along the spectrum. The yellow-forming layer is sensitive to green, the magenta-forming to red, and the cyan-forming to infra-red. The film is reversal processed. So the colours of the transparency are moved one stage back along the spectrum.

A green subject is recorded as blue, a red subject as green, and an infra-red subject as red. All the layers of the film are somewhat sen-sitive to blue. For normal purposes the film is always exposed through a yellow filter, so that blue light does not reach the film. The film can be used with a range of filters for special effects (see page 168).

We always regard IR as a single type of radiation, but it is just as broad a spectrum as is light. Special techniques are available to con-vert the IR spectrum totally to a visible spectrum but here we must confine ourselves to the one readily available system.

Some of the results on Ektachrome Infra-red are predictable, others take us by surprise. Skies come out a deeper blue; green plants come out a bright red; red objects become yellow; mostly neutral parts of the subject often look pale blue or cyan; veins and arteries below the skin show up stark blue and few strong greens appear at all. The most striking deviations from this are in plants. Red or golden autumn leaves turn yellow, white — or even green.

False-colour films for technical photography

False-colour IR photographs are an extension of black-and-white ones. Their major advantage is in distinguishing between differently growing foliage as different colours. Usually the healthiest plants are the brightest red. Some diseases show as a slight darkening; others may result in a deep cyan colour because the foliage reflects no IR.

Radiography

Radiography – photography with short-wave radiation (X-rays or gamma rays) – cannot use conventional optical equipment. The radiation is absorbed by glass, gelatin or plastics. In fact, radiography involves making sophisticated photograms. Conventional filters are not used in the exposure system. However, safelight filters are used in the darkroom, and viewing filters may be used with the radiographs. Radiographic materials are sensitive to blue light, and sometimes to green. Thus, they must be handled in brown or red safelighting.

One system designed for medical X-ray work produces coloured monochrome dye images. By choosing from a range of coloured viewing filters, the radiographer can alter the visual contrast of the radiographs.

Special Effects
Screens and
Lenses

In ordinary photography, you must take the greatest care that your lenses and filters are free from dirt or scratches. Manufacturers ensure that surfaces are true, and the image is exactly correct right across the film. However, on occasions, you may want to distort your image for creative effect. Choosing the right etched, smeared, ground, prismatic or otherwise marked screen allows you to control the distortion.

The effects of these devices are governed by the exact position and orientation of the filter and by the aperture and focus distance of the lens. Naturally, you can use them most easily with a single-lens reflex camera. If you use a direct vision or twin-lens reflex camera, you will have to experiment with your screens before you can be sure of their exact effects.

Most screen suppliers are only too pleased to show you how their products can alter your pictures. However, choosing the effect you want is easier if you have some knowledge of the range available. Also it is possible to make substitutes for some of them.

Diffusers

You can make your pictures just slightly unsharp to give them a soft ethereal look. One manufacturer advises the use of a diffuser to "cover up wrinkles, scars, speckles, etc. found on the skin" when taking portraits of women. In practice, however, the degree of diffusion you need for an attractive portrait is just enough to hide minor blemishes.

In the heyday of the 'portrait attachment', both still and motion picture photographers over-used the device. They really did hide the wrinkles, and most of the expression as well. As a reaction, more modern photographers have tended toward the production of pin-sharp images. Nowadays, the diffuser needs to be used with discretion.

Diffusers may be made of glass, ground to give just the right amount of image spread. Alternatively, they may be engraved with a series of concentric rings, or a regular pattern of small circles. One lens manufacturer supplies a lens with a built-in diffusion facility. You simply turn a control ring to the degree of diffusion you want.

Not all diffusers are even. Some have a clear spot in the middle, graduating to heavy diffusion round the edges. These allow you to picture a sharply focused subject against a dreamy diffused

background. Most are, however, somewhat limited. The area of sharp focus and the degree of diffusion are determined in the manufacture. Thus, you have to arrange your subject to suit the filter. But at least one filter can be adjusted to give the required area of clear glass.

It is, however, easy to produce your own diffusers to give exactly the effect you need. One way is to smear petroleum jelly on a piece of glass – or a UV filter. The more heavily you smear the glass, the greater the diffusion. If you leave a clear hole in the middle and separate the glass from the lens by an inch or two (perhaps mounted on the front of a lens hood) you will get a picture diffused only round the edges. The extent and amount of diffusion depends not only on the area of clear glass, but also on the distance it is set from the lens. The further away, the smaller will be the clear part of the picture.

Other substances, such as black chiffon or net, wire netting, ground glass, and so on produce degrees of overall diffusion. The only way to find out how these affect your pictures is to try them.

Whatever you use to diffuse your pictures, you get the strongest effect if you use a large aperture. The effect of changing the aperture is especially marked on diffusers with a clear central spot. Once the effective aperture is much smaller than the clear area, you get no diffusion at all. If the aperture determined by exposure conditions is too small, you can fit a neutral density filter (see page 103) to let you use a larger one. If the small aperture is necessitated by depth-of-field considerations, you have to use a stronger diffuser – or use two together.

Star screens

Sparkle is added to some pictures by making the bright points flare out into lines of light. This is done with an engraved screen. A series of parallel lines causes flare along the direction of the lines. Two series intersecting in different directions cause the flare to form in two directions, like a star. The filters also have some diffusing effect, softening the picture overall.

The most common star screens have two series of lines ruled at right angles to each other. These produce a four-pointed star from every bright point in the subject. The greater the bright point, the stronger the flare. The size and intensity of the flare is also determined by the lens aperture, being greater with wide apertures. With small apertures, you can get fine sharp rays.

Other screens have three or more series of parallel lines ruled at

149

suitable angles to each other. These produce six or more points on each highlight. But, the greater the number of points, the smaller the stars are. Also, the greater the overall diffusion of the image.

You can make your own star screens by ruling a series of parallel lines on clear plastic sheet. Quarter inch (6 mm) acrilic sheet (such as Lucite or Perspex) is most suitable. Use new sheet of the best quality. Rule parallel lines at about 2 mm ($\frac{1}{16}$ inch) intervals with a suitably mounted needle. Don't score the material too deeply, and try to keep all the lines the same. Make sure that your spacing is even. The angle between your series of lines determines the angle between the rays of the stars.

Of course, even the best plastic is not optically perfect, and you will get some distortion and diffusion overall as well as on the highlights. A simpler method is to smear petroleum jelly on a piece of glass or a suitable filter. Just as you did to make a diffuser, but this time carefully run your finger in a straight line across the surface. Your finger prints will make the parallel lines you need. It is, however, difficult to superimpose another set without obliterating the first. You can, of course, use two pieces of glass, each with one set of lines, and set them together at a suitable angle; or you can smear each side of one piece of glass in different directions.

This technique has the disadvantage that it produces considerable diffusion and rather less striking highlight flare, but it is well worthwhile for experimenting.

One advantage of ruling your own star screens is that you can choose the angle between the rays. You can, however, buy variable double ray filters. One part of the filter remains stationary on the camera lens as the other is rotated to give the angle you want. Star screens produce their most striking effects in pictures with highlights against a dark background. Night pictures spring immediately to mind — street lights, car lights, the moon, and so on, may all become the centres of brilliant stars.

With an SLR camera, decide the aperture to suit the effect you want to create. Fit the filter over the lens and rotate it until the rays are most suitably orientated. If you have a variable angle filter, try altering their angle as well. If you have a static camera support, choose a shutter speed to give you the right exposure. If camera or subject movement determines your shutter speed, you will have to compromise with the lens aperture.

In a movie, you can create an interesting effect by rotating a star screen in front of the camera lens. The stars then rotate around the

highlights. Of course, if you have a variable screen, you can rotate one half, while the other is stationary, the stars then open and close as the rays cross one another.

Diffraction gratings

If the flare is spread not by a cross screen, but by a diffraction grating, it is split up into a spectrum instead of just being one colour. A diffraction grating consists of a series of extremely closely spaced lines.

Unlike star screens, diffraction gratings cause flare across the lines. The light rays diffracted through the grating interfere with one another. This splits up the light into a spectrum – just as if it had come through a prism.

Diffraction gratings are normally used singly. Thus, the flare lines are all parallel to one another. They shoot out in opposite directions from the highlights. The violet end of the spectrum appears nearest the source, then the blue green, yellow and red light. Naturally, the colours are only reproduced if you are using colour film.

You can buy squares of moulded plastic diffraction grating. These can be cut to suitable size for camera use. Often, you can cut several suitably sized pieces from the smallest sheets available. You can then try using crossed gratings, or combining a grating with a star screen. As such procedures depend on the particular materials and conditions, you will have to experiment to find out what is possible.

Parallax correctors

Normal filters have two exactly parallel sides. Wedge-shaped pieces of glass displace the image laterally. Suitably shaped wedges can be used to compensate for parallax in cameras with a separate viewfinder. This is necessary only for close-up photography, because the viewfinder is set to show the correct image area at greater distances. The wedges are normally supplied with close-up lenses for which they are suitable. They should not be used with lenses of any other strength.

Close-up sets for twin-lens reflex cameras may incorporate a wedge in the accessory for the viewing lens. Thus, parallax and focus are automatically linked. Of course, you must always make sure that the viewing lens is fitted the right way up.

Multiple-image prisms

If several different wedges are combined in one piece, each displaces the subject differently. Prismatic accessories are made in this way to give superimposed multiple images.

The number and position of the images is decided by the number and angle of the facets of the accessory. The simplest prism consists of two faces, each at the same angle to the near surface, meeting in a straight line down the centre; rather like the roof of a house. This gives two images. The distance they are separated depends on the angle of the faces; and the direction of separation on the orientation of the accessory.

It is more common to use prisms with three, four, five or more facets. They can be arranged parallel, so as to produce side-by-side multiples. Alternatively, the facets can be equally spaced round the prism. This gives a series of images equally displaced toward the edges of the picture. If the prism has a flat central area, there is also a central image.

Multiple-image prisms with an odd number of parallel facets may have one plane facet in the centre. The central image from this, or from the plane central facet of radially-cut prisms, is stronger and less diffused than the other images.

The displacement of the multiple images depends on the angles of the prism facets; and on the angle view of the prime lens you use them on. The manufacturers design most of these prisms to give pleasing effects with the standard lens on a still camera. If you use a longer focus (narrower angle) lens, the images are wider apart. With a wider angle lens, they are closer together. If you use a movie camera, you are likely to get the most pleasing picture with a slightly wider than normal lens setting (if you have a zoom lens).

The spread of each image also depends on the particular accessory you are using. But it is influenced as well by the diaphragm stop. Basically, the larger your aperture, the more the images spread into one another.

Normal subjects multiplied and superimposed just look a mess. Successful use of these accessories depends on choosing a suitable subject. You need a bold object covering a fairly small part of the field, against a neutral background. An isolated bloom against the sky, for example, or a flower against a fence. Then the multiple images can fill otherwise empty areas of the picture.

The choice of background is important. A bright one will burn out the

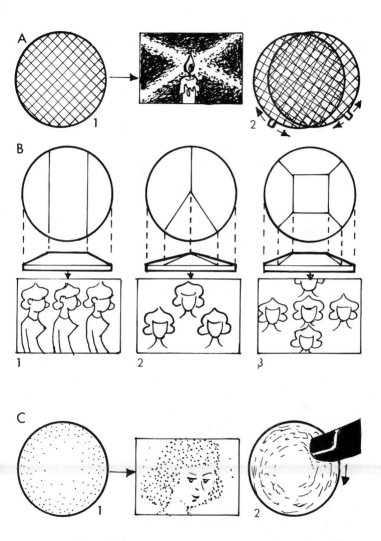

Special effects attachments. A, Cross-hatched optical flats give star effects: 1, fixed cross screen; 2, variable cross screen. B, Prisms split up the image: 1, three parallel facets; 2, three radial facets; 3, five facets with central flat. C, Diffusers soften the image: 1, commercial screen; 2, you can make your own with grease.

film all over, reducing the secondary subject images to mere ghosts — if they are visible at all. Almost invariably, the best multiple-image pictures are those of a bright subject taken against a dark background. Lighted subjects at night can be particularly successful — as long as you leave plenty of empty space for the multiples. A dark wintry sky can be a fine background but a summer sky seldom is — unless you darken it. Use any suitable sky darkening filters (see page 94).

You may get particularly striking pictures with IR film and filters (see page 138). A lone sunlit tree against a blue sky springs to mind. The monochrome IR rendering gives you a snowy white tree starkly pictured against a black sky — a highly suitable subject for multiplying. For close-ups, you can arrange your subject in a suitable paper or cloth background.

When using colour film, the same basic conditions apply. The subject must stand out from the background, which is best dark, and there must be room for the images without too much overlapping. Further, you will find that if the original subject is too gaudy, the picture will be a disaster. This is definitely a case where it pays to restrict the range of colours.

Other distortions

There is no need to confine your image distorters to special photographic accessories. Any transparent objects can be tried — although success depends largely on experiment.

Ordinary window glass is by no means flat. If you search through glass offcuts, you may find some which give you quite interesting effects. Older window glass was less flat than modern glass. And — of course — bulls-eye glass is particularly spectacular.

For greater effects, you can choose from an enormous range of patterned glass. Normally, the simpler patterns — such as straight reeding — give the most effective pictures. As window glass can be bought in large sheets, you can use it up to several feet from the camera. The distance between the camera and the glass affects the image, as does the distance between the subject and the glass.

The optical qualities of patterned window glass are not particularly high. Subjects more than a few feet from the glass tend to be so diffused as to be unrecognisable. Subjects close to the glass may be pictured in a series of patches or lines. This effect is usually more striking

in colour, with a strongly coloured subject.

Glass utensils or ornaments may produce distortions. Vessels filled with water are much stronger lenses than they are empty. In most cases, full or empty, the results are unattractive, and far too diffused. You may, however, be able to find a suitable selection of bottles or glasses to give you exciting pictures.

Mirrors may provide a more fruitful source. Curved reflecting surfaces are found on a wide range of modern products. Cars are particularly well endowed with them — accessory mirrors, wheel discs, bumper bars, and decorative chrome can all be useful. A quick visit to your neighbourhood breaker's yard could provide you with enough distorting mirrors for a lifetime's photography.

To use any non-photographic distortion successfully, however, you need an SLR camera. The effect of the distorter, and the optimum focus, cannot be predetermined. You just have to set up your equipment and move things around till you have the right picture. If in doubt, take a whole series and choose the best results after processing; you'll soon get to recognise the optimum set-ups.

Close-up lenses

If you want to focus closer than your lens usually allows, you can use an accessory lens. This mounts on the front of your camera lens just like a filter or special effect screen.

Close-up lenses are positive lenses. They shorten the focus of the camera lens. As the distance from the lens to the film is designed for the camera lens alone, it is too long for normal photography with the shorter focus combination. Only close-up subjects can be focused sharply.

The strength of close-up lenses is measured in dioptres. A one dioptre lens has a focal length of 1m (1000 mm), a three dioptre lens ⅓ m (333 mm) and so on. Some lenses offer a range of dioptric strengths in the same way as a zoom lens.

If the camera lens is set to infinity, the combination produces a sharp image of subjects at the focal length of the close-up lens. Closer subjects can be focused with the camera's normal focusing ring. Naturally, the figures on the focusing scale are no longer true.

Most comprehensive books on photography give details of the focus distances and subject sizes when photographing with close-up lenses.

Split-field lenses

One special accessory is the split-field lens. Part of it (normally half) is a weak close-up lens; the rest is plane glass. When this is fitted on a camera lens, part of the image is focused close to, and part in the distance.

At suitable distances, you can picture a nearby object sharply against a pin-sharp background. Maybe a flower against a mountain, or a girl's head against a forest.

How close your foreground must be depends on the strength of the lensed half of the accessory. Usually, this is about 1 dioptre. Thus, with the camera focused on infinity, half the field of view is sharp 1 m (3 ft) away.

To use one of these lenses, you really need an SLR camera. Otherwise it is extremely difficult to determine the exact areas covered by the two halves. Focus on your close-up subject, then check your focusing scale and depth-of-focus indicator to make sure that your background will be sharp. If you cannot choose a suitable aperture to give the background sharpness, you will have to move further from your close subject, and refocus.

Once you have focused your lens and chosen your aperture, you can make final changes to your composition. Try to frame your subject so that the 'join' in focus is least visible. You should have as little distinct background within the close-up area as possible. Naturally, you should have none of the close-up subject in the non-lensed area.

Afocal attachments

Converters to alter the focal length while retaining normal focus distances can be screwed into the filter ring of a lens. These are useful to give a different angle of view to a fixed lens. However, most converters change the angle only slightly. Commonly, converters for a 35 mm camera with a 45 mm lens may give a 35 mm wide angle or a 65 mm long focus.

Converters for movie cameras may alter the focal length by a factor of up to about 2. These can thus extend the range of a short zoom lens from say 10–30 mm to 20–60 mm.

Wide angle converters are more difficult to construct accurately. Only the most expensive can make more than a few degrees difference without distortion. For normal photography, they can be recom-

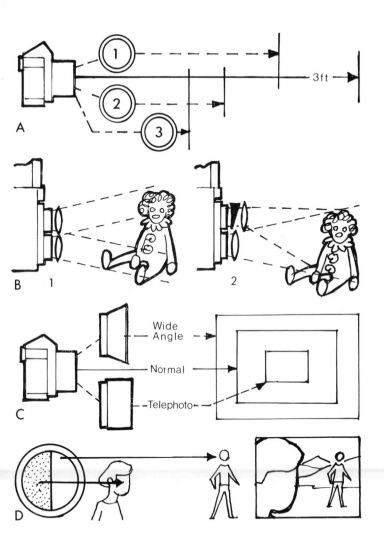

A, Close-up lenses let you picture small objects. B, Sets may incorporate wedges to correct parallax. C, Afocal attachments can change the focal length of a fixed lens. D, Split-field lenses let you focus both foreground and background.

mended only if you have a fixed lens, such as the zoom lens on a movie camera.

However, extremely wide angles are available in special effects converters. Such lenses can give you 130 or 140° angles with a suitable prime lens, or they can convert your standard lens to a fisheye. Usually, these converters can be used with wide-angle lenses for greater effect.

These front-of-lens converters do not normally affect the apertures indicated on your prime lens. Some, however, restrict the maximum aperture you can use. There are no general rules, so if you haven't got the manufacturer's instructions, you must experiment for yourself.

Graduated filters

Often − especially with backlit subjects, you cannot choose an exposure to give accurate rendering of the whole subject: part just has to be overexposed or underexposed, if the important areas are to come out right.

Graduated filters are intended to overcome this problem − in some cases. One end of the filter is quite dense, and the dye then tails off to a plain glass area at the other end. Usually, the graduation is not smooth across the filter. Approximately one-third is evenly coloured, one-third is clear glass, and the intermediate area grades from one to the other. A number of split-field filters are also available. They are divided into two parts, one evenly dyed, and the other plain. They are much more limited in their applications, as the sharp dividing line is usually seen in the picture.

The most commonly used graduated filters are neutral density. They just control the exposure. Coloured filters are also available. These reduce the exposure and alter colour rendering. They are now seldom used with black-and-white films, although graduated sky filters were once popular.

Graduated filters are made in normal rims and in squares for fitting in to holders. Both sorts can be rotated so that the dark part of the filter is at the right edge of the picture. The square filters can also be slid into or out of the holder to alter the proportion of the picture affected. This facility is extremely useful. It would normally be unwise to buy filters in fixed mounts, as their half-and-half effect is over restrictive.

To use these filters, you really need an SLR camera. You can then rotate or slide the filter until it colours or darkens part of the view-

finder image as you require. There is no reason why you cannot use a filter to darken an already dark subject, thus gossly overexposing the already pale unfiltered part. You can combine graduated filters to darken or colour, say, the top and bottom of a scene, or you can use a graduated filter with any other filter or accessory.

To calculate the exposure through a graduated filter, measure only the light from whatever part of the subject you want to come out a normal density. Unless this is to be pictured through the dyed part of the filter, do not make any adjustment to the exposure. If it is to be taken through the dense part, modify your exposure using the information supplied by the filter manufacturer. Unless there is no other way, you would be advised not to take meter readings through the filter.

Screens in the darkroom

So far, we have assumed that screens are used on the camera lens. In fact, you can also use them in the darkroom. Camera lens accessories are not likely to produce successful pictures if you use them on your enlarger, but you can print through patterned glass, gauze, cloth, perforated zinc and so on. Also, you can buy any number of specially prepared texture screens for this purpose. You can also buy miniature screens to put in your negative carrier.

You will find detailed descriptions of these screens in books on creative darkroom technique. However, basically you can either project your negative through the screen, or make separate exposures of the screen and the negative.

Pictures made through the texture have a white screen pattern on them. Pictures made with two separate exposures have a black pattern. Naturally, if you use the same screen, the black pattern is the reverse of the white one, i.e. the black bits are in the same places that the negative is printed in a combined print.

If you use a large screen (in contact with the paper) you can make the texture more diffuse by raising it slightly from the paper.

Special Effects
in
Colour

You can use all the special effects screens described in the previous chapter for colour as well as for black-and-white. There are also a number of special colour-only filter tricks. For many of these to succeed, the exposure needs to be just right. There really is no way bar experiment to decide what gives you the picture you want. If in doubt, bracket your exposures by at least one stop each side of your calculated setting.

Altering the colour

If you use a strongly coloured filter with colour transparency film, you get a strongly-coloured transparency. Although bright red pictures of Auntie perhaps won't go down very well, there are many more suitable ways to use vivid colour. You can use yellow, or orange, to portray tropical heat, green and blue for cooler scenes.

One special use of blue filters is in simulating moonlight. Take a colour transparency through a dark blue filter without making the usual exposure compensation; this gives quite a good moonlit effect. It is especially successful with townscapes or snow-covered scenes. If you include the sun in the picture you may get an even better result.

Pictures actually taken at night are particularly suitable for colouring. Often they come out as a series of points of light against a black background. Through a coloured filter, they can become brilliant points of colour.

Fireworks are quite colourful to the eye, but may be rather disappointing on a colour transparency. You can get absolutely brilliant colours with suitable filters.

Try leaving your shutter open for several seconds, and use a different coloured filter for each burst of fire. This can produce a most colourful display; but beware of overdoing it. Pictures full to the corners with sparkle – coloured or otherwise – can be confusing. Like any other subject, you need discretion, and when you are superimposing each firework separately, you may not realise quite what a mess you are making.

One particularly striking subject is a sunlit landscape – photographed directly into the sun. Set your exposure to suit the sky exposed through the filter. The sun is so brilliant that it will over-expose the film and produce a white image. Foreground subjects, such as trees or ironwork tracery, are pictured in silhouette. So your final picture shows a burning white sun in a strongly coloured sky, sited behind a

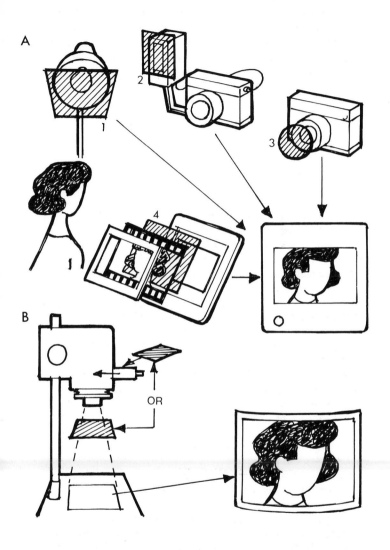

Adding colour. A, For transparencies: 1, use coloured lights or 2,
coloured flash; 3, use a filter on the camera or 4, bind a piece of colour.
B, For prints: use an abnormal colour pack when printing, or change
the times for a tricolour exposure.

silhouetted foreground. Of course, you must set the exposure right, usually about one stop less than that calculated from the filter factor should give a good rich sky colour (don't try to meter the sun, though.) Often the sun looks rather insignificant in a photograph. Although its brilliance gives it a special significance to our eyes, it really covers a very small arc of the sky. When you include it as a feature of your pictures, you can make it come out much bigger if you use a long focus lens.

Colour prints

There is no reason why you shouldn't add the colour when you are printing from a colour negative. A CC70 or so deviation from the neutral filter pack gives you an almost monochromatic picture — resembling a colour transparency taken through a primary colour filter.

However, there is little point in exposing colour negatives through strong coloured filters if you are going to have them processed commercially. The automatic printing machines will compensate within their capabilities to remove the colour you have added. You will just get a rather grey looking picture. If you want brightly coloured prints, you have to make them yourself. Even prints from transparencies lose much of any extraordinary colour if they are made in a photofinishing laboratory.

Binding in filters

One way to colour transparencies is simply to mount a piece of filter with them. Quite ordinary pictures can be given a fire all of their own by this method. It is particularly suited to silhouettes, where your main subject then stands out against a vivid yellow, red, blue, or any colour, background. If a scene strikes you as suitable for this treatment, overexpose a transparency by a stop or so. When it is processed, the slightly light picture is ideal for combining with a suitable colour.

Naturally, pieces of filter to be mounted must be clean, but slight defects may go unnoticed. It is a good idea to save any suitably-coloured gelatin filters if they get damaged. Usually you can cut out a large enough piece to bind in with a transparency.

Additive colour photography

You can make a full-colour print with three separate exposures through red, green and blue filters (see page 187). Similarly, you can make a colour transparency or negative with three exposures on one frame.

You put the camera on a tripod, and make three successive exposures through red, green and blue filters. Unless your camera has a multiple exposure device, you will have to fiddle with it to overcome the double exposure prevention mechanism. An old roll-film camera with no double-exposure lock is particularly suitable. Cameras with Everset type shutters make multiple exposures simple. With colour reversal film, the three exposures are very critical. Together they determine the density of the transparency. The relationship between them gives the colour balance. In practice, the exposures are so difficult to decide that it is not really worth attempting to use transparency film. With colour negative film, the final colour balance is set in the printing stage. Thus the exposures are nowhere near so critical.

You can use any set of filters suitable for making colour separations: 25, 61 and 31A; 25, 97 and 98; 70, 74 and 98 etc. The exact balance between the exposures depends on the series you choose. As a starter, take a meter reading without filters, and then give one stop more through each filter. For example, on a sunny day colour negative film normally needs about $\frac{1}{125}$ at $f11$. Give instead $\frac{1}{125}$ at $f8$ through each of the three filters. After you have taken a few pictures you will be able to devise your own exposure calculations. If you print your own negatives, aim to produce your three-colour negatives to print with your normal filter pack.

The Harris shutter

You can make a special multiple filter holder called a Harris shutter to simplify the technique. Mount three pieces of filter one above the other in a cardboard strip. Leave solid card at each end. This strip slides through a holder fitted to your lens. The holder is a flat slot-shaped cardboard box with a suitable lens-mounting ring at the top. It has a square hole opposite the mounting ring. The filter slide is slotted into the box. If it is held up, it blocks all light from the lens. When it is released, it falls past the lens, letting red, green and blue light reach the film in turn through the three filters. When it comes to rest at the

bottom of the holder, the light is once more cut off. A baffle on the top of the filter strip prevents stray light from reaching the lens. To get consistent exposures, you must make sure that the strip can fall smoothly and evenly down the box.

The rate at which the filter strip falls is not constant. Usually, if you put the blue filter at the bottom, followed by the green and then the red, you get about the right proportions. If your negatives are difficult to print, or you want to make transparencies, you can alter the relative sizes of the three filters.

To use the Harris shutter, fit the holder to your lens with the mounting ring. Put the filter strip in so that the bottom card blocks the lens completely. Open the shutter (use B or T); let the filter strip fall; and close the shutter. The aperture you need to get a suitably exposed negative depends on the size of filters you use, and on the ease with which the strip falls. You will have to find the right ones for you by trial and error. However, a good starting point is the aperture you would set for an exposure of $1/30$ second. Thus, with colour negative materials on a bright day, $f22$ is probably about right. Since few modern lenses can be stopped down so far, you need a neutral density filter so that you can use an aperture on the available scale.

An $8\times$ filter (3 stops, ND0.9) or $16\times$ (4 stops, ND1.2) takes you on to a suitable aperture range in bright sun. For your first trials, bracket your exposure by one and two stops each side of the calculated aperture.

Subjects

When you make a triple-exposure negative, any part of the subject which has *not* moved comes out in its normal colours. Anything in a different place for the three exposures is recorded as three separate coloured images. Thus, the technique is wasted on totally static subjects. It also produces indistinguishably muddled images from normal moving subjects. Naturally, it is totally inapplicable to movies.

The most popular subject for this technique is water. You shoot a still landscape with the sparkle of water as the only moving part. The landscape comes out in its natural colours, but the water is a mass of coloured sparkles. Not only are there strong red, blue and green highlights, there are cyan, magenta and yellow patches where two colours are superimposed.

To the uninitiated, the effect is so bizarre as to appear non-

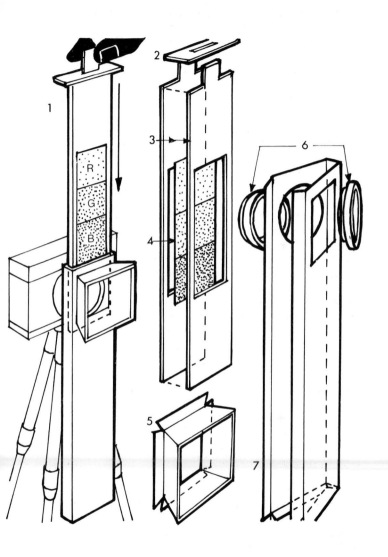

The Harris shutter for making three-coloured exposures in the camera.
1, Card slide. 2, Stop. 3, Filter mounts. 4, Red, green and blue filters. 5,
Card lens hood. 6, Mount to fit lens. 7, Card tube holder for filter slide.

photographic. Yet it is difficult to imagine how hand-work could have produced such brilliant colours. Even to the experienced photographer who can recognise the technique, the effect can transform an otherwise dull picture.

False-colour films

Infra-red Ektachrome film is described on page 144. It is a false-colour infrared-sensitive colour film designed to be used with a yellow filter. It will, however, produce interesting pictures with other filters.

Without a filter, the film produces an overall magenta or violet colouring. Little if any of the subject is recorded in strong saturated colours. In fact the 'washed out' look is somewhat akin to that you get with tungsten light colour film outdoors (without a filter).

The recommended yellow filter (12, K2) produces a more deeply coloured result. Except for vegetation, the overall colour is a cyan-blue. Neutral-coloured parts of the subject come out almost the same colour as the sky, and few colours are very distinct. Green foliage, however, comes out a strong crimson and red objects tend to come out yellow.

For special effects — rather than for strictly scientific work — a pale orange filter is often more useful. The overall blue comes out rather more cyan; the foliage more red, and red objects a more distinct yellow or green. Yellow or white parts of the subject which also reflect IR come out white on the film. You can, however, further alter the colours by using any strongly-coloured filter. Red filters restrict the colours to reds and yellows, although often these are rather dull, dirty colours. The deeper the red, the cleaner the colours. Visually opaque IR filters give a totally red picture. Green filters are usually disappointing. They confine the picture to blues if they are strongly coloured; paler filters give some violets or purples.

If you are starting off with the film, try an orange filter, such as a 15 (G) or 21. In daylight, expose as if for a 100 ASA film (measure without the filter). In morning or evening light, which is strong in red and IR, give about half a stop less than the meter suggests. In tungsten light, give about one stop less (or set the meter to 200 ASA). These suggestions are suitable if you use a selenium or silicon meter. They may give under-exposure with a CdS meter, which is especially sensitive to red light. As with any other film, you can't really get exactly the pictures you want unless you make some tests with your equip-

COLOURS PRODUCED ON INFRA-RED EKTACHROME
THROUGH A YELLOW-ORANGE FILTER

Colour	Without IR reflection	With IR reflection
White Yellow	Blue-green	White
Red Purple	Green	Yellow
Green Blue-green	Blue	Crimson/purple
Blue Black	Black	Red

ment, and alter your exposures to compensate for your preferences. With the orange filter, the colours of parts of the picture are determined by the visible colours of the subject, and by their IR reflectance. The table above gives a guide as to the colours you will get. Naturally, if your subject reflects IR only partly, your picture will come out part way between the two colours listed. You can't see the IR so you can't tell until the film is processed.

Exposure

Whatever film you use, with or without filters, it gives good results only if it has the correct exposure. For normal purposes, you should base your exposure settings on the quoted film speed (ASA or DIN number). Naturally, you will modify the actual figure to account for processing conditions, variation in your equipment, and your preferences for lighter or denser results.

When you use a filter over your camera lens, you reduce the radiation reaching the film. Except with the palest filters (UV absorbing, skylight, CCO5Y etc.) you must modify your filterless exposure to produce a negative or transparency of your normal density.

There are two ways of determining the required exposure with a filter: measure the light reflected from the filter; or calculate the exposure in the normal way and alter it to account for the published factor for the filter.

Through-the-lens meters

If you have a camera that measures exposure through the lens (or through a cell which is covered by any filter) it is simplest to measure through the filter. In most cases this gives a satisfactory result. However, if you use a strongly-coloured filter, you may not get quite the right exposure. Meter cells are not exactly like film (or the human eye) in their spectral sensitivity. In particular, CdS cells are more sensitive to longer wavelengths (yellow and red). Thus, the meter may be misled.

Normally, the effect will be so slight as to have no significance, but on reversal films, the difference in density may matter. If this is likely to be so, it is better to calculate your exposure from the filter factors.

Filter factors

Manufacturers list factors for their filters. These represent the amount the exposure needs to be increased to compensate for light loss in the filter. Because different light sources produce light with differing spectral compositions (see page 39), some filters have different factors in differing conditions. Theoretically, the factors also vary with film types. In practice, you can use the same factors for all modern panchromatic and colour films.

The factors are exposure multipliers. They can be applied directly to

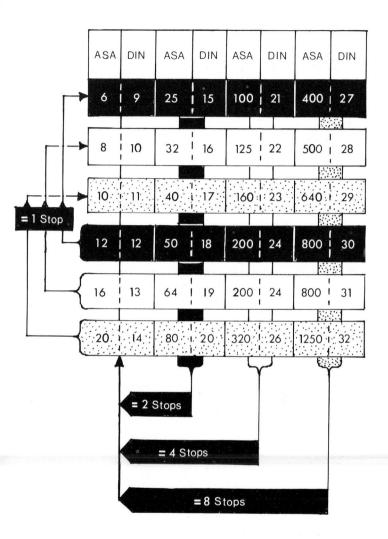

Film speeds. Automatic camera may have their exposure changed by changing the film speed setting. Reducing the speed increased the exposure. Each jump of three steps alters the exposure by 1 stop, equivalent to a 2 × exposure factor.

Filter	Code	Daylight Filter Factor	_or_ Exposure Increase (Stops)	Tungsten Lighting Filter Factor	_or_ Exposure Increase (Stops)
UV-absorbing		1	0	1	0
Skylight		1	0	1	0
	1A	1	0	1	0
Amber colour-compensating	81A, 81B	$1\frac{1}{4}$,	$\frac{1}{3}$,	$1\frac{1}{4}$,	$\frac{1}{3}$,
	81C, 85	$1\frac{1}{2}$,	$\frac{2}{3}$,	$1\frac{1}{2}$,	$\frac{2}{3}$,
	85B	2	1		$\frac{2}{3}$
	85C	$1\frac{1}{2}$	$\frac{2}{3}$	$1\frac{1}{2}$	$\frac{1}{3}$
	82A	$1\frac{1}{4}$	$\frac{1}{3}$	$1\frac{1}{4}$	$\frac{1}{3}$
	82B, 82C	$1\frac{1}{2}$,	$\frac{2}{3}$,	$1\frac{1}{2}$,	$\frac{2}{3}$,
Blue colour-compensating	80A	3	$1\frac{2}{3}$	4	2
	80B	3	$1\frac{2}{3}$	3	$1\frac{2}{3}$
	80C	2	1	2	1
	80D	$1\frac{1}{4}$	$\frac{1}{3}$	$1\frac{1}{2}$	$\frac{2}{3}$
All colours*	CC05, CC10, CC20,				
	CC30Y, CC40Y	$1\frac{1}{4}$	$\frac{1}{3}$	$1\frac{1}{4}$	$\frac{1}{3}$
Yellow					
Cyan	CC30C, CC40C				
Magenta	CC30M, CC40M, CC50M				
Yellow	CC50Y				
Red	CC30R, CC40R	$1\frac{1}{2}$	$\frac{2}{3}$	$1\frac{1}{2}$	$\frac{2}{3}$
Green	CC30G, CC40G				
Blue	CC20B, CC30B				
Cyan/Red	CC50C, CC50R				
Green/Blue	CC50G, CC40B	2	1	2	1
Blue	CC50B	$2\frac{1}{2}$	$1\frac{1}{3}$	$2\frac{1}{2}$	$1\frac{1}{3}$
Fluorescent†	FL-D	2	1		
Light yellow	3	$1\frac{1}{4}$	$\frac{1}{3}$	1	0
Light yellow	4, 6 (K1)	$1\frac{1}{2}$	$\frac{2}{3}$	$1\frac{1}{2}$	$\frac{2}{3}$
Yellow	8 (K2) 9 (K3) 12	2	1	$1\frac{1}{2}$	$\frac{2}{3}$
Yellow	15 (G)	$2\frac{1}{2}$	$1\frac{1}{3}$	$1\frac{1}{2}$	$\frac{2}{3}$
Yellow-green	11 (X1)	4	2	4	2
Deep yellow-green	13 (X2)	5	$2\frac{1}{3}$	4	2
Green	58 (B)	6	$2\frac{2}{3}$	6	$2\frac{2}{3}$
Deep green	61 (N)	12	$3\frac{2}{3}$	12	$3\frac{2}{3}$
Blue	47 C5	6	$2\frac{2}{3}$	12	$3\frac{2}{3}$
Blue	47B	8	3	16	4
Deep blue	50	20	$4\frac{1}{3}$	40	$5\frac{1}{3}$
Light red	23A	6	$2\frac{2}{3}$	3	$1\frac{2}{3}$
Red	25 (A)	8	3	5	$2\frac{1}{3}$
Deep red	29 (F)	16	4	8	3

*Except: Yellow CC05Y, no increase, Blue CC20B $1\frac{1}{2}$ × ($\frac{2}{3}$ stops)

†In daylight type fluorescent lighting.

the shutter speed. For example, with a 4× filter, you need to give $\frac{1}{125}$ second instead of $\frac{1}{500}$ without the filter (at the same aperture). Note that a factor of 2 × indicates a 1 stop exposure increase (e.g. from $\frac{1}{125}$ to $\frac{1}{60}$ second), and so on.

If you want to alter the lens aperture instead of the shutter speed, you must remember that each stop you change *doubles* or *halves* the exposure. Thus a 4× filter needs a two stops larger aperture (*not* 4 stops larger). The table of neutral density filters on page 105 gives aperture changes equivalent to a series of filter factors.

The filter factors and their equivalents in stops are only suggestions. Whenever possible, ascertain the filter manufacturer's recommendation. Use this in preference to any other. Better still, make a series of test exposures with your own equipment and filters. When you see the results, you can draw up a table of filter factors that is exactly matched to your needs.

Modifying the film speed

A simple way of calculating the exposure you need with filters is to alter your film speed setting to suit. As this is just another way of using filter factors, you measure the light *without* a filter.

On both the ASA/BS (arithmetical) and DIN (logarithmic) speed scales, each step up the scale indicates that one third of a stop less exposure is needed in the same lighting conditions. Thus each three steps indicate a halving (or doubling) of the film speed.

To modify the film speed, simply reduce the number you use by three jumps for each stop extra exposure your filter needs. Thus using a 4× (2 stop) filter with a 125 ASA/22 DIN film, set your meter scale to 32 ASA/16 DIN. In sunny conditions, the meter will show about $\frac{1}{125}$ at f16 for 125 ASA film, and about $\frac{1}{30}$ at f16 for 32 ASA.

Filters
for
Microscopy

Filters are used in microscopes both for viewing and for photography. Microscope objectives are often less rigorously corrected than are camera lenses. Thus, they produce really sharp images only if they are combined to a narrow waveband. For viewing, green or blue filters are often used; these both sharpen the image, and reduce eye strain.

Monochrome photography

With panchromatic film, you can choose exactly the light you want to give you the optimum sharpness and contrast. Sets of suitable filters are made. One allows you to choose relatively narrow wavebands of violet, blue, blue-green, green, yellow-green, green-yellow and three different wavelengths of red. Some of the wavebands are isolated by single filters, others with pairs.

Most microscope objectives are best corrected for yellow-green rays (about 540 nm). Thus you get the sharpest pictures using a yellow or green filter. Yellow or yellow-green filters also have the advantage that they transmit the rays most easily seen. So a visually focused microscope is suitably focused for photography.

The narrower the waveband, the sharper the picture, if the image is focused suitably for the photographic emulsion. The 540 nm region for which the best objectives are corrected can be isolated with 58 and 15 filters together.

The disadvantage with narrow waveband filtering is that there is so little light. You may have to focus without the filters, and thus risk not getting it exactly right. Also exposure times may be very long, and thus the filtration totally unsuited to moving specimens.

If you have to focus without the filter (because it absorbs too much light), make sure that you focus suitably for photography. If you are using a filter that isolates yellow or yellow-green light, visual focus is suitable. With any other colour, you have to alter the focus one way or the other. Thus, your microscope must have an accurately calibrated fine focus adjustment.

Contrast filters

With stained, or otherwise coloured, specimens you may want to enhance the contrast with suitable filters. All the normal rules of using contrast filters also apply to a microscope (see page 96).

Microscopists also have their own suggestions. For example, the skeletons of small insects tend to transmit red and infra-red much more than blues or violets. Thus red filters give them great transparency, and blue filters emphasis their characteristics.

Colour films

Most of the normal rules for colour filtering apply to photomicrography. The colours, however, do not always need to be corrected so accurately. The exact red colour of a carmine stained *Obelia* is not as important as the exact representation of a bridesmaid's yellow dress. You should, however, use a film of suitable colour balance for the lighting you are using, or use a suitable colour correcting filter (see page 48). When subtle colours are important you can use colour compensating or colour printing filters.

With normal films, colour photomicrographs are often disappointing because the subject contrast is too low.

The special Kodak Colour Micrography film gives much higher contrast than normal colour films. Thus, many of the low contrast problems are now solved. However, this film makes little pretence to giving a true colour balance. Batch-to-batch variations are high. If you want to reproduce your subject exactly the right colour, you will have to make a series of tests with CC filters (see page 81). Then you will have to use suitable filtration with film of the same batch number.

Types of filter

In microscopy – both visual and photographic – the filters are normally put in the light-beam below the slide. Thus, they do not have to be of optical quality. Any suitably coloured material can be used. It may be slotted into the lamp, or held by a swivelling ring just below the substage condenser.

Gelatin filters are rather fragile, and eaily damaged if you mount them on a lamp. Dyed-in-the-mass glass filters are much more robust. Usually the substage filter mount takes 32 mm circles, and microscope illumination lamps 50 mm squares.

How you mount your filters depends on the type of illumination system you are using. A condenser mount is needed if you are reflecting between the mirror and an artificial light source. Microscopes

with integral illumination systems have to have their own filters suitably mounted. In the last resort, you can use a good quality filter on the stage immediately below the slide.

If you can't get suitable solid filters, you can use liquid filters. Make up a solution of a suitable colour, and put it in a plane-sided cell. You can make a suitable cell by clamping two pieces of acrylic sheet together with a U-shaped bend of 20 mm ($\frac{7}{8}$ inch) diameter rubber tubing between them.

Interference filters

Because microscopy often needs very narrow wavebands of light, many normal absorption filters are very dark. Monochromatic filters absorb so much light that they cause severe problems. Interference filters, however, can combine the same selectivity with much greater transmission (see page 201).

Neutral density filters

Microscopy is often done without an iris diaphragm in the light path. Thus, if you need to control the light intensity, you may need to use neutral density filters. This is particularly likely if you are using a simple shutter mechanism with no choice of speeds; or if you are photographing by electronic flash.

For most uses, simple photographic silver density is quite adequate. Alternatively, you can use a set of photographic filters. As you are not using them in the image-forming light beam, you can combine as many as you want. A suitable set might consist of 0.3 (1 stop), 0.6 (2 stops), 1.2 (4 stops) density filters. Combining these, you get from 1 to 7 stops exposure decrease (see page 104).

Filters
for Colour
Printing

Colour print materials work in the same way as colour films. They form the colours as a mixture of cyan, magenta and yellow dyes in three layers of the emulsion. Just as with colour films, you can alter the colour balance by colouring the light to which they are exposed. Since no care is normally taken to ensure that colour negatives have exactly the right balance, filters are essential if you are to achieve a suitable colour when making a print. In fact, printed directly on to colour paper most colour negatives would produce an overall orange or red picture.

Thus, when making colour prints, you have to control the colour of the printing light as well as the time and intensity. Unless you are using an enlarger with a built-in colour head, you will need to use colour compensating (CC) or colour printing (CP) filters. An alternative to separate filters is proved by the Janpol-Color enlarging lens. This lens has two graduated filters built in. One runs from yellow to cyan, and the other from yellow to magenta. Turning a dial for each one racks it across until the right section appears in the lens. In use, the two filters are simply side by side. They are situated toward the back of the lens, and their colours integrate completely. However, the lens must be used at its full aperture ($f5.6$) for effective colour printing.

The dials are calibrated in CC units – up to 120 cyan, and 120 magenta, or 240 yellow on either filter. Using two graduated filters with yellow on both allows all usable filter combinations, but prevents the accidental inclusion of any neutral density – see page 186.

There are two ways of using coloured filters: subtractive or white-light printing, and additive or 3-colour printing.

White-light printing

In white-light printing, you give the print a single exposure to the negative and a suitable selection of subtractive (cyan, magenta or yellow) filters. The exact composition of the filter pack needed to give the correct colour balance must be chosen by trial-and-error methods.

However, you can start in the right sort of way. Usually, you need a magenta or red filter pack. Older masked films such as Kodacolor–X, and Agfacolor CNS need about 50M + 20Y. Newer films such as Kodacolor II or Agfacolor pocket special need a stronger more red pack. 80M + 80Y (i.e. 80R) is recommended for Kodacolor II. Further, colour paper is packed with information on how it differs from manufacturer's standards.

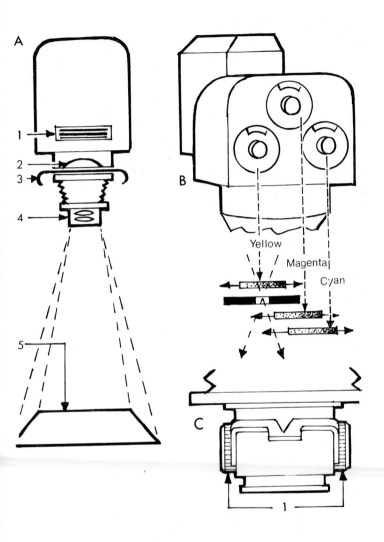

White-light colour printing. A, Filter drawer enlarger: 1, filters; 2, condenser; 3, colour negative; 4, lens; 5, colour paper. B, Colour head. Turning dials alters proportions of each colour in the mixed light. C, Janpol-Color lens. Turning the controls (1) moves filter wedges through the lens to colour light.

The paper box carries filter pack change recommendations in the form of additions or subtractions of filters. (It also has exposure factors to assist you in getting the right exposure, and 3-colour adjustment factors.) To use the filter pack adjustments you add or subtract them from your basic filter pack. If you are starting from scratch with a negative of a type needing a basic 80M + 80Y, and a paper marked +20M − 10Y, use 100M and 70Y for your first trial.

If you have already been making colour prints, you will know your normal filter pack requirements. When changing to a new batch of paper, reduce this to a basic filter pack by removing the adjustments for the batch you have been using; then you can add those for the new batch. For example, if you normally need a 40M + 50Y filter pack, and your paper has an adjustment of + 10M, 0Y, your basic pack is 30M + 50Y filter pack.

Set up your enlarger to the enlargement you want, and use a suitably representative part of the negative area. Make a test strip of 3 or 4 different exposures with your calculated filter pack, and process it. Now try to decide on the correct exposure and the filters you need. You decide the exposure from the density, just as you do with black-and-white printing. You decide the filter pack changes from the colour balance of your test strip.

Basically you must add filters of the colour(s) in excess in your test. Thus − if it is too yellow, you add more yellow to the filter pack. If the picture is too blue, you need to add blue; but you can achieve the same effect by subtracting yellow (the complement of blue).

Always rationalise your filter pack to the lowest density (see page 186). If the changes needed have not been too great, you can now try a full-sized print.

Viewing filters

If you have a slightly off-colour print, one way of determining the filters you need is to look at it through a selection of filters. Go into a fully-lit area, preferably in daylight. You can use your colour printing or colour compensating filters for viewing. Hold them well away from the print, so that light shining through them does not colour it. When you have decided through which filter the print looks best, add its complement − at half its strength − to the filter pack. Thus − if your print looks best through a 20M filter, you need to add 10G to the filter pack. This is best achieved by removing 10M.

FILTER RECOMMENDATIONS FOR SUBTRACTIVE
COLOUR PRINTING

Colour Cast		Correction needed	Filter pack change*
Yellow –	weak	05–10Y	Add 05Y or 10Y
	moderate	20–30Y	Add 20Y or 30Y
	strong	40Y+	Add 40Y
Magenta–	weak	05–10M	Add 05M or 10M
	moderate	20–30M	Add 20M or 30M
	strong	40M+	Add 40 M
Cyan –	weak	05–10C	Remove 05Y + 05M or 10Y + M
	moderate	20–30C	Remove 20Y + 20M or 30Y + 30M 1
	strong	40C+	Remove 40Y + 40M
Blue –	weak	05–10B	Remove 05Y or 10Y
	moderate	20–30B	Remove 20Y or 30Y 2
	strong	40B+	Remove 40Y
Green –	weak	05—10G	Remove 05M or 10M
	moderate	20–30G	Remove 20M or 30M 3
	strong	40G+	Remove 40M
Red –	weak	05–10R	Add 05Y + 05M or 10T + 10M
	moderate	20–30R	Add 20Y + 20M or 30Y + 30M
	strong	40R+	Add 40Y + 40M.

Weak cast – visible only in pale neutral areas; *Moderate cast* – visible except in areas of strongest colour; *strong cast* – picture more-or-less one colour all over.

*Assuming original pack has only magenta and yellow filters. All colours are made from cyan, magenta and yellow.

1. If necessary add cyan filters.
2. If necessary add cyan and magenta filters.
3. If necessary add cyan and yellow filters.

Exposure

Adding filters to the pack increases the time needed to give the same exposure. Removing them reduces it. Each filter has its own exposure factor, and you should alter your calculated time to account

APPROXIMATE EXPOSURE FACTORS FOR
FILTERS USED IN COLOUR PRINTING

filter	Factor	Filter	Factor
05Y	1.0	05B	1.1
10Y	1.1	10B	1.3
20Y	1.1	20B	1.6
30Y	1.1	30B	2.0
40Y	1.1	40B	2.4
50Y	1.1	50B	2.9
05M	1.2	05G	1.1
10M	1.3	10G	1.2
20M	1.4	20G	1.3
30M	1.7	30G	1.4
40M	1.8	40G	1.5
50M	2.0	50G	1.7
05C	1.1	05R	1.2
10C	1.2	10R	1.3
20C	1.3	20R	1.5
30C	1.5	30R	1.7
40C	1.6	40R	1.9
50C	1.9	50R	2.2

Note that these factors apply for papers, and may differ from the film exposure factors for the same filters.

for filter changes. Simply divide your calculated exposure time by the factor for any filter you remove, and multiply it by the factor for any you add.

If the changes are small, this should give you the correct exposure. If they are large it will give you the basis for a new test strip.

Rationalizing filter packs

Always make sure that you use the lowest density filter pack that you can. Otherwise you will need excessive exposure times. Cyan, magenta and yellow filters together add up to neutral density. So if your filter pack contains all three colours, remove equal densities of each so that only two colours remain. Thus a 70M + 40Y + 20C pack is the same colour as 50M + 20Y.

This is especially important if you are using CC filters below the enlarger lens. In this case, always use the smallest number of filters possible. CC filters are supplied in red, green, and blue as well as cyan, magenta and yellow. So you can nearly always reduce your coloured filters to two or three only.

The effect on the colour balance is identical, whether you add one colour to the filter pack, or subtract its complement (in equal density).

Cyan filtration

It is unusual to need cyan filters, except for making small adjustments together with a magenta or yellow filter. If you need strong cyan in your filter pack, this probably indicates that too much infra-red radiation is reaching the paper. To prevent this, use an infra-red absorbing filter or glass. Infra-red absorbing filters for colour printing are usually made of optical glass, and should be mounted below the enlarger lens. Once fitted, one can be left in position permanently.

Three-colour printing

A different approach is to give the paper three successive exposures through primary red, blue and green filters. The exposure time through each filter is varied to control the colour and density of the print.

You determine the three exposures with a series of test-squares.

Set up your enlarger for the enlargement you need, and focus a suitable negative area on to a square. Turn off the light, and expose a piece of colour paper. First give 10 seconds through your blue filter. Then make a 3 or 4 step exposure test from side to side through your green filter. (Say 10, 20 and 40 seconds.) Then give a similar set of exposures from top to bottom through the red filter. Repeat the identical green and red tests with a series of blue exposures on different sheets of paper – perhaps 15, 30 and 45 seconds. With care, you can make four test grids on one (8 × 10) sheet of paper.

After processing, you can identify your exposures by the colour. Longer blue exposures make the print more yellow overall; the successive steps through the green filter give an increasingly magenta image; and increasing the red exposure colours the picture a stronger green.

Look at your test prints in normal lighting. Decide which sector gives the right colour and density. (Naturally, the optimum may be in between two of your steps; as it can be with black-and-white test strips.)

Once you have decided on the exposures you need, you can make a full-size print. Often, you will be able to make prints from several similar negatives with exactly the same exposure times.

When you have made a print, you may want to make another with improved colour balance. Increasing the exposure time through a filter increases its complement (see page 21) in the print. It consequently increases the overall density as well. Thus, you have to decide through which filter to increase the exposure, and whether to compensate by decreasing that through the other two.

Filters

Colour printing is done with either colour printing or colour compensating filters.

Colour printing filters are made of dyed acetate or gelatin. They are accurately coloured but not accurately flat, and are for putting in the enlarger head. Some enlargers have a filter drawer to hold them. In others, you can lay the filters on the condenser. These filters are available as cyan, magenta, yellow and sometimes red. Blue and green are made by mixing cyan and magenta or cyan and yellow.

The filters for white light printing are made in a series of densities. They are named by their density to light of a complementary colour. Thus a CP10M filter is a magenta filter of density 0.10 to green light. Additionally, there are UV and IR absorbing filters. It is normal to use a UV-absorbing filter (such as a CP2B) for all white-light printing. The IR-absorbing filter – such a CPIR-1 – is used only if needed.

Colour compensating filters are similar, but are optically finished. They can be used in an image-forming light beam (such as below an enlarger lens). They are made in a series of densities in all six colours.

If you use these filters held below your enlarger lens, always use the smallest number possible. The greater the number, the greater the loss of definition caused by reflections from the multiple surfaces. Even using the fewest possible filters, this method is not particularly suitable for white light printing, because of the difficulties of handling filter packs without damaging the filter surfaces.

Filters below the lens are normally used for three-colour printing. As

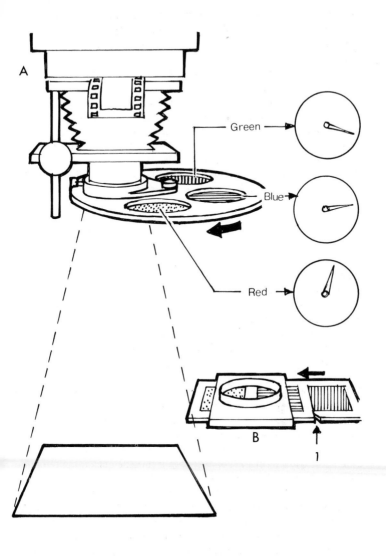

Green

Blue

Red

B

1

Three-colour printing. A, The paper is exposed for suitable times through each of the three primary filters. B, An alternative filter-holder.

you need only three, and they are used separately, the chance of damage is much reduced. Also, you have to change from one to the next in the dark without disturbing the enlarger. This is difficult with filters in the enlarger head. In fact, the primary red, green and blue filters you need can be selected from the gelatin filters made for use over the camera lens.

When you first get these filters, put adhesive tape along one edge, and *always* handle them by this tape. Cut distinctive notches in them so that you can tell their colours in the dark.

You may find a simple card or plastic holder attached to your enlarger makes three-colour printing easier.

As primary filters absorb both infra-red and ultra-violet radiation, you need no extra filters except the normal heat absorbing glass built into most enlargers.

Exposure determination grids

A number of aids to subtractive colour filtration and exposure are available. They consist of a series of tiny pieces of filter held in a grid. They also have a neutral density wedge, at one edge of the grid.

You put your negative in the enlarger, with the calculated filter pack in the filter drawer. Focus the part of the subject you wish to print. Fit a diffuser (usually supplied with the grid) below the lens. Put the exposure grid on top of a piece of fresh colour paper on the baseboard, and give a suitably timed exposure.

After processing, the paper shows a series of differently coloured dots or patches. One of these is a neutral grey. Usually, the grid is supplied with a matching mask so that you can be quite sure which one of the exposure spots is neutral. The grid is calibrated so that you can read off the filter pack correction from the area that gave a neutral grey. Make this correction and you will have a suitable pack for printing the negative – in most cases.

The image of the neutral density wedge is calibrated to indicate the exposure time correction you should make. The indicated exposure time should be modified as necessary to account for the filter pack changes. Naturally, if the original exposure was wildly wrong, you can't really tell much even from the colour patches.

The technique depends on diffusing the negative image to give a uniform tone. With a normal subject, the tones *integrate* (mix) to a neutral mid grey. However, if the subject does not integrate to a

neutral grey, the grid indicates the wrong filter pack. For example, a girl wearing a red dress will come out with a cyan tinged face if you follow the grid.

If the subject integrates to a darker or lighter than normal tone, following the density wedge gives the wrong exposure time. For example, a scene taken through a shaded opening (which occupies a large area of the picture) will come out too pale overall.

These problems are not confined to recommendations determined from exposure grids. They happen with any method which involves integrating the negative tones and colours. Commercial printing machines normally base their filtration on such methods. Thus, unusual negatives are often not printed very well.

If the subject is an unusual colour, it is referred to as a 'colour failure negative'; if the tones are unusual, it is a 'subject failure negative'. These terms imply that there is something wrong with the negative, but this is not so. It is simply that if you use an integration technique, you get a suitable filter pack and exposure time only with negatives of 'normal' subjects. Identifying negatives that need a change from the 'normal' recommendation is one of the most important skills of colour printing.

Filters for densitometry

Densitometry is measuring the density of an image − on film or on paper. The measuring instrument is called a densitometer. It is widely used in scientific work, and in exposure measuring systems for making prints.

Colour densitometry works by measuring the density (consecutively or simultaneously) through three primary filters. The balance between the three readings is a measure of the colour. Densitometers are calibrated with reference to standards, and thus the figures they produce can be interpreted.

The three primary filters used are of major importance. Several series are internationally defined. Each is used for a different medium. They are collectively known as *status* filters.

Status A filters are used for transmission densitometry of transparencies, particularly those intended for projection.

Status D are for making reflection–density measurements from colour photographs.

Status G are for making similar measurements from coloured ink pictures (i.e. books, posters etc.)

Status M are for use in densitometers measuring transmission in masked colour negatives.

Each of these series consists of a slightly different set of red, green and blue filters. Other sets may be chosen for other purposes. Other status filters are used for specialist monochrome densitometry.

Safelight
Filters

Photographic materials are sensitive to light, but not all materials are sensitive to light of all colours. By restricting the ambient light in *colour* and *intensity* you can create a situation in which you can see, but the material you are using is not fogged; at least in a fairly short time (not more than 4 minutes).

Safelamps

Each manufacturer has his own specifications. But, with the exception of sodium lights, most types allow the choice of a number of coloured filters for different uses. Small lamps use jam-jar sized coloured bulb covers. Larger ones use sheets of filter material.

Never fit a larger bulb than the manufacturers recommend. Doing so can lead to an unacceptably high level of illumination — thus making the light 'unsafe'. It may also result in overheating of the unit. This can warp the fitting or its filter, allowing light to escape unfiltered, and so unsafe; and it can be dangerous — leading to fire or to the production of noxious fumes. The normal recommendations are for 15 or 25 watt bulbs.

The intensity of light is related to the distance away of its source. Follow the manufacturer's distance recommendations carefully. In the absence of any clear instructions, never take sensitized materials closer than 1½ meters (5 ft) in the direct light from a safelight. You can safely increase the illumination level by reflecting safe lights from light-coloured walls or ceilings.

For overall lighting, you can use suspended safelamps. The sodium vapour type are particularly suited for this use with black-and-white papers.

Filters

The choice of colour is determined by the spectral sensitivity of the sensitive material: the choice of intensity somewhat by its speed. Materials sensitive to only part of the spectrum (such as single speed black and white paper, or orthochromatic film) can be used in suitably coloured lighting. Panchromatic materials and colour materials are sensitive to light of all colours, and can be handled only in the faintest of lighting. High speed materials should by handled only in total darkness.

Normal black-and-white papers can be handled in a pale green-

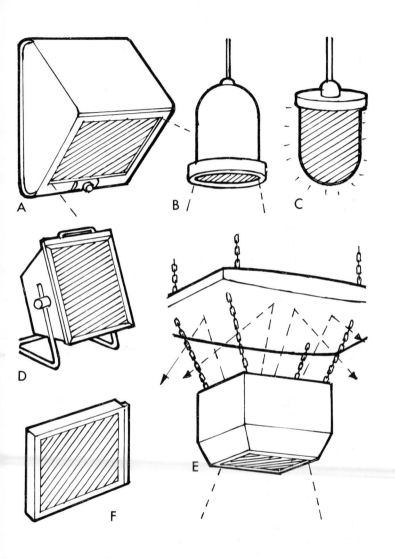

Safelamps. A, Wall unit. B, Pendant type with flat filter. C, Pendant with moulded filter. D, Bench light. E, Large ceiling light with reflector. F, Modern slim-line unit.

amber safelight. Variable contrast papers – which can have their contrast altered by filters (see page 200) – need a slightly darker filter. Orthochromatic material can be handled in deep red lighting. Panchromatic materials cannot theoretically be exposed to any colour without fogging. In practice most materials have a slight dip in sensitivity at about 500 nm—i.e. in the green. This is one of the highest points of human sensitivity, so you can use a very deep green light with some success when handling slower panchromatic materials. Colour materials differ, and the only suitable light is an extremely dim brown. Faster – camera speed – panchromatic and colour materials can be handled only in total darkness.

SAFELIGHTS

Material	Filter colour
Contact printing papers Blue sensitive copy films	Yellow-green or pale amber.
Projection (enlarging) papers Bromide or chlorobromide	Amber or olive green.
Variable-contrast papers	Amber
Orthochromatic materials (lith films etc.)	Ruby red
Panchromatic papers Very slow panchromatic films	Dark green
Medium speed panchromatic films	Very dark green or dark bluish-green
Colour print materials	Very dark amber or dark brown.
Fast panchromatic films Colour films	Total darkness.

The table above gives typical safelighting recommendations; where these differ from a manufacturer's suggestions, use the latter. If a film or paper manufacturer has a specific recommendation for a particular material, don't use an alternative unless you know it is an exact equivalent, or produces less light. Always observe total darkness instructions. The table gives the colour of the light required. With

tungsten bulbs, this is also the colour of the filter. If you use a sodium safelamp, or other special type, follow the maker's instructions as to the filters needed to produce a particular quality of safelighting.

Cumulative exposure

The fogging effect of exposure to safe-lighting (or any other lighting) is cumulative. A particular exposure may not produce any visible darkening if the material is processed immediately. It may, however, result in a slight darkening of highlights and mid-tones if the material is subsequently exposed in the normal way to a negative before processing.

To test your safelighting: expose a sheet of the fastest material you intend to use so that it will develop to a mid grey (or to a normal print); leave the paper under safelighting (at the recommended distance); put a coin or similar object on the paper, and leave it for twice the maximum time you would expect to use the safelighting. Process it normally. If your lighting is unsafe, you will see a paler image of your coin on the print. In this case, either use a lower power bulb in your safelamp or a darker filter.

Materials

Safelight filters are manufactured from dyed gelatin, glass or acetate sheet; or from moulded plastics of the required colour and density. All these materials are suitable for most uses. Don't use glass, however, if it has any chance of being splashed with water. Naturally, safelight filters are not manufactured in optical qualities suitable for use on camera lenses.

Intermittent lamps

A number of manufacturers supply flickering safelamps. These are designed to produce safe lighting at a higher perceived light intensity – in other words, you can see better, despite the light remaining safe. These lights are usually produced for specific applications, e.g. black-

and-white printing or colour printing – and do not need any extra filters. If you follow the manufacturer's instructions, these lights are very successful. But do not try to convert them from one use to another simply by adding a possibly suitable filter.

Special
Filters

Most filters are made of optically flat glass, plastic or gelatin dyed to absorb radiation of certain wavelengths. Some filters, however, depart from this definition. Most of them have specialist applications, but some are at least of passing interest to the photographer.

Ghostless filters

One of the problems with using a filter is that it may introduce flare or ghost images. Surface coating (see page 208) reduces this, but cannot eliminate it entirely. One solution to this problem is to curve the filter, so that any reflection from its inner surface is absorbed by the interior of the lens barrel. Unfortunately, producing accurately curved filters is expensive. However, at least one camera manufacturer supplies a curved 'ghostless' skylight filter.

Filter bags

With a flash-gun, you can use the filter over the flash instead of over the camera lens. If you do not want any unfiltered spill, you can put the flash unit into a suitably coloured bag.
A particular use for filter bags is in infra-red surveillance photography: a multi-layer bag which transmits no visible light is put over the flash. Thus, the flash is not seen by the subject. Some filter bags are constructed so that one side gives IR, and the other UV.

Filters for variable contrast papers

There is considerable contrast variation among black-and-white negatives. Thus, the optimum print can be made only if the contrast of the printing material can be chosen to suit the negative. Some types of paper are sold in a number of contrast grades. As an alternative to this, filters can be used with variable contrast papers.
Variable contrast papers have a combination of two or more differently sensitized emulsions. Generally, a low contrast blue-sensitive one and a high contrast yellow- or green-sensitive one. Both emulsions produce similar black-and-white tones.
The balance between the two emulsions is determined by the colour of the printing light. Each make of paper has its own recommended

series of coloured filters. These are used singly to produce the required contrast. As the grades of normal papers are numbered to indicate their contrast, so are the filters used with variable contrast papers. Such filters may also provide intermediate contrasts.

Variable contrast filters are made either in gelatin, for use below the enlarger lens; or in acetate for use in the enlarger head, like colour printing filters (see page 182).

Heat-absorbing filters

Heat-absorbing filters absorb infra-red radiation, while passing light. They thus reduce the heat from a light source without decreasing the light output and are widely used to protect films in the gates of projectors or enlargers.

Heat-absorbing filters are normally made of glass, It is difficult to make them in true optical quality, so most are not suitable for use in an image-forming light beam. They should be used between the light-source and the film to be projected. Alternatively, one or more of the condenser elements may be made from a heat-absorbing material.

One problem with such material is keeping it cool. The heat it absorbs must be dissipated evenly; otherwise the filter may crack. Thus, it is unwise to put a heat-absorbing filter into an enlarger or projector which was not designed for one.

Colour print materials are sensitive to IR. They are usually protected from it by the heat absorber in an enlarger, but if they are not you need a filter (see page 187).

Interference filters

Thin coatings can produce interference between reflected and transmitted light. This is used to reduce reflections from lens surfaces, but may also be used to produce accurately controlled light transmission. Multilayer interference filters are made for scientific uses. They are far more precise than the needs of normal photography dictate. These filters also have another major advantage: they transmit more light than equivalent absorption filters. This is especially significant in narrow band pass filters — or monochromatic filters. As the wavelengths transmitted depend on the exact angle of incidence, interference filters can be used only in carefully set up equipment.

Dichroic mirrors are a special type of interference filter. They reflect part of the spectrum, and transmit the rest. By controlling the interference-producing layers, the manufacturer can select the exact point of cut-off between reflected and transmitted wavelengths. Two specific types sometimes used in photographic equipment are *cold mirrors* which reflect UV and light, but transmit IR and other long wavelengths; and *hot mirrors* which act in the opposite way. Either may be used to provide a heat-free light source for projection or printing equipment.

Liquid filters

The range of absorption and transmission characteristics of normal filters is limited. When exact requirements cannot be met for scientific purposes, liquid filters may provide the answer. Cells of liquid (usually water) with suitable substances dissolved in it can be calibrated very accurately. The cells must be constructed of suitable transparent materials, and have two accurately parallel plane sides. A cheap way to provide light of a particular colour can be to shine a white light through a glass vessel containing coloured water. The water can be coloured with paint or dyes (such as cooking colours). Remember, however, that a round vessel of water acts as a lens, and concentrates the light – usually in a rather irregular way.

Christiansen filters

Instead of dyes, transparent particles suspended in a liquid can act as a colour filter. These provide the scientist with a further range of accurately controllable filters.

Materials
and
Mounts

Apart from the special types already described, filters are normally transparent homogenous materials, dyed or otherwise coloured to absorb radiation of particular frequencies.

Materials

For photographic purposes, filters are usually made from gelatin, glass or transparent plastics.

Gelatin filters are manufactured by dissolving suitable dyes in liquid gelatin. This is then coated on glass, allowed to dry and stripped off. This produces accurately flat filters – usually about 0.1 mm thick. The thickness usually varies by less than 10 per cent.

These filters are not very strong, and can be marked easily. Most manufacturers lacquer their filters to give them greater resistance to abrasion, but they must still be handled with the utmost care.

Glass sandwich filters are made by cementing one or more gelatin filters between two pieces of optical glass. They are suitable for using on camera lenses, and strong enough to be carried around with an outfit. Such filters have the abrasion resistance of glass filters or lenses. One special danger, however, is that the gelatin may absorb water through its edge. This causes it to swell and distort the filter.

Glass filters made from optical glass incorporating colouring agents can be treated just like lenses. Because of the difficulties of finding dyes which can stand the temperature needed for casting glass, these filters are normally available in far fewer colours than gelatin filters. They can be used just like the glass sandwich filters.

Acetate filters may be coloured with dyes incorporated in the plastic, or in gelatin coated on the surface. However they are made, these filters are seldom homogenous. Thus, if used in any image-forming system, they tend to diffuse the image. As they are not necessarily perfectly flat, they may also introduce distortions. Acetate filters are intended for colouring light sources. Their uses include: converting studio lighting; colouring the light to be used for colour printing; or in safelights, although many safelight filters are coated on to a glass support.

Optical plastic filters have been made by a number of manufacturers. These filters, which incorporate the colouring, are difficult to make. They are, however, lighter and less liable to be broken than equivalent glass filters. No doubt as the technology improves, these filters will become more widespread. At present, however, they are prohibitively expensive.

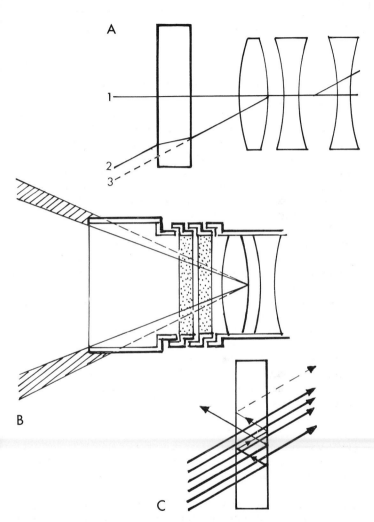

Unintentional Effects of filters. A, Although normal rays (1) go straight through a filter, oblique ones (2) are deviated slightly, thus the image is minutely displaced (3). B, A combination of accessories may have too narrow an acceptance angle, so produce vignetting in the corners of the picture. C, Unwanted reflections can introduce flare and ghost images.

Qualities

Each manufacturer has his own definitions of filter qualities. Basical-
ly, for ordinary photography you only have to consider whether or not
a filter is suitable for use in an image-forming light beam. Glass and
gelatin photographic filters are intended for such use.

Glass filters of specially high quality are made for the motion picture
industry. These are needed only with exceptionally long focus or wide
angle lenses. Some filters for scientific or technical use, called optical
flats, are made to unnecessarily high standards for photographic use;
others may not be of high enough quality to give good definition if
used with a camera. In practice, if you buy *photographic* filters from a
reputable manufacturer, you are unlikely to have any problems.
However, it is wise to examine any filter to make sure that it does not
contain bubbles or have visible irregularities in its surfaces.

Gelatin filters made specially for graphic arts purposes are excep-
tionally consistent in thickness and optical flatness. This is essential
for photomechanical reproduction processes, which depend on the
production of three identically-scaled copies made through three
different filters. However, the filters are unnecessarily expensive for
ordinary photography, and normal photographic quality materials are
perfectly adequate.

Non-photographic filters can be made in glass, gelatin, or a number of
different plastics. They are not manufactured to give a good image,
and may produce diffusions or distortions if you use them on a
camera or enlarger lens. They include: colour printing filters, for use in
enlarger heads; studio filters, for use over light sources; theatrical
lighting filters; and safelight filters.

Optical effects of filters

Any substance through which an image-forming light has to pass can
alter it. Slight distortions in filters can give image distortions of the
type you commonly see through ordinary window glass. Naturally,
these distortions are minute with a properly-made filter.

All filters deviate the light path of rays passing through them oblique-
ly. This effectively magnifies the edges of a subject. Also, it makes edge
rays more highly coloured than those that pass straight through the
filter.

Like other smooth surfaces, those of a filter can reflect light. As they

Filter mounts. A, Slide for squares of gelatin. B, Screw-in rim. C, Push-on rim. D, Adapter ring for other sizes. E, Filter holder in bayonet mount lens hood. F, Screw-together holder for a set of filters.

are normally fitted right at the front of the lens, filters are particularly vulnerable to light from bright objects just outside the subject area. Thus they are liable to cause flare, and may also give ghost images. Both these effects result from multiple reflections from the filter surfaces. Modern camera lenses are often deeply recessed, and you may well not be in the habit of using a lens hood. When you have a filter on the front of your lens, it is virtually essential to fit a hood to shield it from oblique light.

Surface coatings

All modern lenses are given at least one anti-reflection coating on each surface. Such coatings use interference phenomena to suppress reflections. Many lenses now use a combination of several microscopically thin layers to suppress the reflections even more. With uncoated lenses, pictures taken into the light tend to lack contrast and show flare spots or streaks. These defects are reduced – but not entirely eliminated – by the coating.

Most good quality glass filters are also coated, and some have multiple coating. If you find that your filters increase flare defects in your pictures, you should first try using a lens hood. If this is not effective, you will have to use coated, or multiple-coated filters.

Filter mounts

The important feature of any filter mount is that the filter be easily and securely fitted to the lens. Some mounts are designed to hold any of a set of unmounted filters. Such mounts include screw-together adapters to take round filters, and slot-in holders for square filters.

More often, however, glass filters are permanently mounted in rims which fit directly on to the camera lens. The rims screw, bayonet or push on to the lens rim. Although some camera manufacturers have their own specifications, most can be used with filter rims from a standard range.

Most ranges of rims are identified by their diameter size, measured in millimetres. Many camera manufacturers are standardizing as many as possible of their interchangeable lenses to the same size, 46, 49, 52 and 55 mm screw mounts are common with 35 mm interchangeable lens cameras and Super 8 cine cameras. Filters in the

Temporary mounts. A, Adhesive tape is sometimes useful. B, A lens cap can provide a ready-made push on ring. C, A slot cut in a lens-hood is suitable for some filters.

standard ranges are made so that a similarly mounted filter or accessory can be fitted to them. Thus, a 52 mm screw mount filter carries a lens type 52 mm thread on its front surface. This allows you to mount a second filter, a lens hood, or other accessory.

In most cases, camera lenses can be fitted with push-on accessories 2 mm larger than their screw-in size. So a lens taking 55 mm screw-in filters takes 57 mm push-on ones.

Temporary mounts are needed for occasionally-used gelatin filters. You can use sticky tape (on the remote edges only of the filter), but this is not always convenient or secure. If you often want to use one of a range of filters, you can make up a simple card slot-in holder. Alternatively, a lens hood with a slot cut in the top is quite convenient. For this you will have to cut one end of your filters to a semicircle. Put tape along one edge of your filters before you use them. Otherwise they are difficult to handle without damage.

More frequently used filters can be mounted in semi-permanent frames for ease of handling. These are available from filter manufacturers or you can make them yourself from stiff card. Such frames are suitable for slotting into frame holders on lenses.

Adapter rings

If you have a set of lenses which take different filter sizes, you may be able to use filters with adapter rings, commonly known as stepping rings. These are rings which screw into a lens filter ring of one size, and allow you to fit a filter of another. Always buy filters suitable for your largest-diameter lens and fit them to your smaller lenses with appropriate stepping rings. The other way round, you may cause edge cut-off – or *vignetting*.

Vignetting

Using the wrong lens attachment, or the wrong combination of attachments, can lead to vignetting. The picture is darkened or cut off at the corners. The effect most commonly arises from using a lens hood made for a longer focus lens. It can also be caused by using filters or other attachments too small for the lens.

If you use several filters together, and then put on a lens hood, you have extended the hood much farther than usual from the lens. This

too can lead to vignetting. When you use a new combination of accessories, take care that they do not obstruct the image in this way. The danger is greater with wider angle lenses.

If you use a reflex camera, you may see the effect of the accessories on the viewing screen image. (With a twin-lens reflex, of course, you must look at the effect with the accessories fitted to the viewing lens.) Alternatively without a film in the camera, you can open the back, hold the shutter open on B, and make sure you cannot see your accessories through the film aperture.

Built-in filters

Extreme wide angle and fisheye lenses present a problem with filters. The extreme angle of the outermost rays means that they would pass through the filter at a considerable angle. They therefore take a much longer path through the filter and are affected to a greater extent than are those which pass through perpendicularly. This can lead to an intensification of the filter effects in the corners of the picture.

A further complication arises from the fact that many such lenses have bulging front elements, and are thus totally unsuited to fitting plane filters.

This problem is overcome by building in a set of filters. They are placed within the lens, at a point where the light rays are more-or-less parallel. Small pieces of filter are needed, and appropriate colours are chosen by rotating an external control. Almost invariably the lenses are constructed so that they need a filter of some sort in position. When no special effects are needed, you must select a UV or skylight setting of the ring. If you want to use a different set of filters you must get a lens specialist to adapt your lens.

Extreme long focus lenses also present a problem. Their front elements are so large that filters are difficult to make. Most manufacturers overcome this problem by making provision for screwing in small filters at the back of the lens. Quite normal filters are used — usually between 30 and 40 mm in diameter.

As with the wide-angle lenses, most long focus lenses with rear-mounted filters must always have a filter in place. Again, a UV or skylight filter is used when no special effects are wanted. You can, however, get suitable filters for most special effects, or have specific filters mounted for your lens.

Care
and
Handling

Filters are fragile and easily damaged. Once their surfaces have been distorted or scratched, they are useless for most purposes.

Gelatin filters

Although they are protected by a lacquer coating, gelatin filters should be handled only by the edges or the extreme corners. Once they have got finger prints on them, they are virtually impossible to clean. They are sensitive to abrasion, and when scratched, must be consigned to the bin (or at best to use in an enlarger colour drawer). You should be particularly careful to keep them dry. Moisture, even just a damp atmosphere, can make gelatin cloudy. Likewise it can easily be damaged by heat or stress. Either can produce distortions making a filter optically unsatisfactory.

One particular problem of filters used on lights is that they tend to fade. If you use gelatin filters to colour lighting exactly, don't leave the filters in front of the lights except when you are actually photographing. Acetate studio or theatrical filters do not fade so quickly.

The best way to store gelatin filters is between the paper they are supplied in. You can slip the wrapped filter between the pages of a book for safe keeping. Never wrap the filter in ordinary paper. It may contain substances which bleach the dyes.

Gelatin filters are made only in sheets or squares. If you need to, you can cut them to shape. Hold the filter firmly between two sheets of stiff paper and cut the sandwich with sharp scissors. You can draw the required shape on the paper before you start cutting.

Acetate filters

Filters made from dyed or coated acetate are not normally intended for use in the image-forming light beam. They should be treated with respect, and stored in clean conditions away from bright light. Small abrasions are unlikely to affect their performance. Be especially careful, however, with polarizing filters (usually an acetate sheet). The polarizing properties can be destroyed by heat – even that given out by an ordinary lighting unit (see page 119).

Colour printing filters can be treated in the same way whether they be acetate or gelatin. However, you must take extra care to keep the gelatin ones dry. Storage in a clean dry drawer is usually satisfactory.

Glass filters

The condition of your filters is as crucial as the condition of your lenses. Glass filters should be accorded all the care you give lenses. Then they will last as long.

If feasible, store your filters in the maker's boxes, or in soft-lined pockets of your gadget bag. Alternatively, if you carry several filters the same size, you can screw them together. Front and rear caps are available to protect stacks of filters. These screw into the threads.

However you pack your filters, make sure that nothing is touching their surface. If anything is touching them, the vibration from walking or travelling in a car or train can produce irreparable damage within a few minutes.

Cemented sandwich filters need all the care of ordinary glass filters, and they must be kept scrupulously dry as well. The cement and gelatin can absorb moisture through the edges. This makes the gelatin swell, and can let air in between the glasses, ruining the filter. Even if air does not get in, the stress can make the sides no longer parallel. Sandwich filters are always lacquered round the edges, but this is no sure protection.

A further limitation on this type of filter is that the cement starts to melt at about 40° C (100° F). At temperatures much above this, the adhesion breaks down and the gelatin can contract within the glasses. Apart from severe tropical conditions, such temperatures are only liable to occur if a light source is focused on the filter. If you use such filters with high power sources – for example in photomicrography – make sure that this does not happen.

Cleaning filters

Your filters *should* never need more cleaning than a light dusting with a blower brush. However, rarely can anyone achieve such a standard of permanent cleanliness.

The first approach to removing dirt is simply to breathe on the filter and polish it *gently* – with a clean soft cloth. If this does not produce results, you must resort to lens cleaner. Moisten a soft cloth or lens tissue with a reliable lens cleaning fluid; and lightly rub the filter. Be careful not to touch the edges of cemented sandwich filters.

If this does not work with solid glass filters, you can try soap and water (not detergents or abrasive cleaners). This may get the dirt off

without damaging the filter. If you do damage it, you are no worse off if it was previously useless because of the dirt.

Even a dampened lens tissue is a last resort with gelatin filters, and is unlikely to remove stubborn stains without destroying the filter.

Tropical storage

In damp warm climates, fungus tends to grow on almost anything. Photographic gear is no exception, and gelatin filters (alone or sandwiched) are particularly susceptible. Keep them (and the rest of your equipment) scrupulously clean, and as cool and dry as possible. Whenever possible, put them in a sealed container with a suitable dessicant. For example, keep them in the container with your films.

Interpreting
Scientific
Data

Electromagnetic radiation

Radiation travels in straight lines, but each ray has a wave motion. It vibrates in a sinusoidal fashion, exactly in one plane. Any normal radiation source produces a bunch of rays each vibrating in their own plane. To make life even more complicated, in some cases radiation behaves as if it were in minute particles – or packets of energy which scientists call *quanta*. The infinitesimally small quanta of light are called *photons*. Their application to photography is restricted to discussion of the theoretical basis of image recording. For our practical purposes, we need think only in terms of wavelength.

The vibratory motion of radiation describes what mathematicians call a *sine curve*. The wavelength is the distance from any point on the curve to the next identical point: i.e. from one peak to the next, or from one trough to the next.

The wavelength of radiation observable, with instruments, ranges from 10 000 km (extremely long radio waves) down to about a 10 000 000 000 th of a mm (cosmic rays, measured in 100s of femto metres: 1 fm $= 10^{-15}$ m). We can see radiation with wavelengths from 400 to 700 nanometres (nm $= 10^{-9}$ m, or one millionth of a millimetre). That is only a tiny part of the continuous electromagnetic spectrum, we call it light.

Radiation between about 1 nm and 400 nm is called ultra-violet (UV). Below 1 nm come X-rays, gamma rays and cosmic rays. Radiation below about 330 nm can be disregarded for normal photographic purposes as it is absorbed by ordinary optical glass camera lenses. Thus UV photography normally means photography with radiations between 330 and 400 nm.

Radiations longer than 700 nm and up to about 100 microns ($1\mu = 10^{-6}$ m) or $^1/_{10}$ mm are called infra-red (IR). Above 100 microns come microwaves, and radio waves. UHF radio and TV come at the long end of the microwave region; VHF transmissions next from about 100 mm to 1 metre. Shortwave up to about 150 metres, medium wave about 180 to 600 m, and long wave about 1000 to 2000 m. Longer waves still may be used for telephone and other communication systems. Often radiations of longer wavelength than IR are measured in frequency rather than wavelength. Frequency (in hertz) is the number of vibrations in a second; it decreases with increasing wavelength.

Photographic materials are not naturally sensitive to IR or longer wavelengths, but IR film is specially sensitized. Usually, it is made

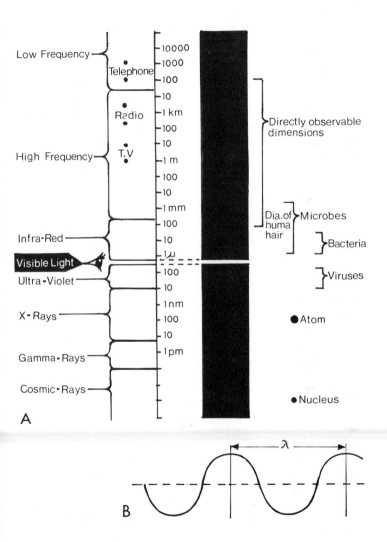

The electromagnetic spectrum. A, The properties of electromagnetic radiation depend on its wavelength. Light is only a minute part of the spectrum. B, Radiation has a sine-wave vibration. λ is its wavelength.

responsive to wavelengths only just longer than visible light (i.e. up to about 800 nm) but the range can be extended (up to about 1150 nm) in special purpose materials.

Light

As described above, we see as light the electromagnetic radiation between about 400 and 700 nm. This is the portion of the spectrum with which we are most concerned in photography. An even mixture of all wavelengths looks white. Uneven mixtures, or isolated bands, are colours.

The sensitivity of films, and the absorption of filters, can be expressed in terms of amounts of different wavelengths. This is far more precise than a simple description, such as 'dark red' or 'pale bluish green'. It is, however, of little use to those who cannot interpret the figures.

Problems of choice

For most photography, the simple description is quite suitable. It is not good enough, however, for scientific purposes. You also want a more scientific definition if you are to decide between two apparently similar filters. If you actually have the filters, you can look through them side by side, and decide which might be more suitable: alternatively, you can make photographic tests.

However, if you are choosing a special filter from a catalogue, you need as much information as possible. One manufacturer, for example, describes eight different filters simply as 'green'; and a further nine as light, deep, or dark green. True, the catalogue does give suggested uses for most of them. But if you want one for some other use, these verbal descriptions are not too helpful. Nor are the overall descriptions of films as blue-sensitive, orthochromatic, panchromatic, red panchromatic etc.

Spectral sensitivity curves

The sensitivity of a film can be plotted on a graph against the colour of light. For a modern panchromatic film, the graph has a peak somewhere in the yellow or yellow-green area. This matches the sen-

sitivity of the eye quite closely, being but a little higher at the blue end and lower around the yellows.

It is easier to make a comparison with the sensitivity of the eye if the latter is plotted as a straight line. This shows the relationship just described for panchromatic films. Other types of emulsion deviate further from the straight line (see page 75).

Blue sensitive film starts just above the 'eye-line' but drops sharply in the blue-green (from about 470 nm). In fact, it is virtually insensitive to any light but blue and violet.

Orthochromatic film starts dropping in the green (about 510 nm), and its sensitivity goes down more or less progressively in the red. Its low sensitivity to yellow and orange distorts the tone rendering of these colours considerably. The film is almost totally 'blind' to red (i.e. wavelengths above about 600 nm).

Red-panchromatic film had extra red-sensitivity. Its sensitivity curve rises well above the 'eye line' from about 600 nm onward.

IR-sensitive film is much like red-pan films, with a sensitivity extended beyond the visible spectrum.

Colour films

Colour films consist of three separate emulsion layers, each sensitive to a different spectral band. Typical curves overlap somewhat but — with the inbuilt filtration — their sensitivities are from about 380 to 500 nm, from 500 to 600 nm, and from 600 to 720 nm. The sensitivities are not uniform between these limits. They are tailored so that their peak sensitivity corresponds as closely as possible with the peak absorption of the dye that will form on processing. The aim is that the dye in each layer should absorb exactly the colour to which the emulsion is sensitive. So the spectral sensitivity curve and the dye absorption curve should match exactly.

The dyes used in colour photography are not perfect. Balancing their actual colour absorption properties against the colour sensitivity of the emulsions is an important part of film manufacture. In most colour negative films, some of the dye-formers are made to remain coloured in areas where they are not converted into dyes. This gives the negatives a characteristic red-orange colour. Its purpose is to compensate for deficiencies in the dye absorption curves. Thus a more accurate colour print can be made.

With modern colour films, the differences between sensitivity and

dye absorption are balanced out. So most normal subjects come out very well. Their colour is closely matched in the print or transparency. Unfortunately, what the eye sees as a particular colour can be a single waveband, or be made up from a mixture of wavelengths in any number of combinations. Most combinations produce an equivalent combination on the film. Some don't.

The most commonly encountered aberrant reproduction is that of some blue flowers. Although a strong blue to the eye, colour film renders them a somewhat insipid pink or purple. This is sometimes called the *Ageratum* effect after a common American flower, but equally applies to bluebells and many other species.

Similarly, the visual effect of a filter may not be duplicated exactly on a colour film. Even apparently identical filters from different manufacturers may affect a film differently.

Comparing curves

The most exact way to predict the effect of a filter on a film is to make a series of test exposures. However, you can get some idea of the likely results by comparing the absorption curve of the filter with the sensitivity curve of the film.

You get the most suitable comparisions if you use the film curve expressed in terms of visual response. You can compare this with the total absorption curve of the filter. This shows you the way that the filter affects the visual rendering of the subject.

Thus, panchromatic film has excess sensitivity in the blue/violet region of the spectrum. This is where a yellow filter absorbs light. If you put the two curves one above the other, you can choose a yellow filter with a closely matching curve.

The units of absorption and sensitivity are not always compatible. So, although you can see the approximate effect of a film and filter combination, you may not be able to predict the precise result even by comparing the curves.

With colour film, you have to consider the effect of the filter on each of the three layers separately. This is especially important with strongly coloured filters. Mauve and purple filters transmit both blue and red light. Only by comparing exactly what wavelengths they transmit with exactly which wavelengths the emulsion layers respond to can you predict their effect.

Naturally, filters cannot transmit light that does not fall on them. To

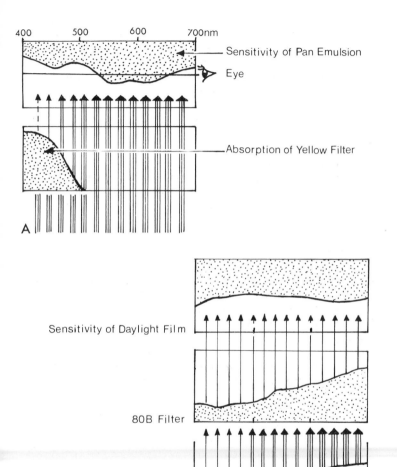

Comparing curves. A, The curve for a yellow filter matches more or less that of panchromatic film. B, The curve for a blue conversion filter is computed to match that of studio lighting, so altering the light to suit daylight film characteristics.

223

discover how a filter affects light from a coloured object, you must know the reflection spectrum of that object. Exact data is rarely available, except in laboratory surroundings. Most natural objects reflect a fairly even band of wavelengths centred on those of their predominant colour. You may, however, know one or two factors which may be relevant. For example, living plant tissues reflect infrared and deep red strongly. This affects colour films more than it affects the eye; and, of course, is seen strikingly in infra-red photographs (see page 138).

Transmittance curves

Filter manufacturers publish curves for their products. These are commonly transmittance curves, showing the log of the light transmitted at all wavelengths throughout the spectrum. The transmittance is defined as the ratio of the light passing through the filter to that falling on it. The curves are usually calibrated in percentages from 100 to 0.1 – often plotted on a logarithmic scale. Transmittance may, alternatively, be expressed as a fraction of 1; thus 60 per cent is equivalent to 0.6.

Two other measures of filter characteristics are used: *Absorption* is the complement of transmittance. Thus, a transmittance of 75 per cent can be expressed as an absorption of 25 per cent.

Density is the light-stopping power of a material. It is the logarithmic of the reciprocal transmittance (as a fraction of 1). So –

$$\text{Density} = \log_{10} \frac{1}{\text{transmittance}}$$

For example, a transmittance of 25 per cent is equivalent to a density of $\log \frac{1}{0.25} = \log 4 = 0.602$.

Density is a particularly useful measure when combining filters. When two or more filters of the same colour are added together, their combined density is calculated simply by adding together their individual densities.

Some data is calibrated in both transmittance and density. Occasionally density alone is used. With a little care, you can usually convert one type of calibration to any other. Often, however, it is the shape of the curve that matters. As long as you know which line represents total absorption and which total transmission, you don't really need to bother about the units.

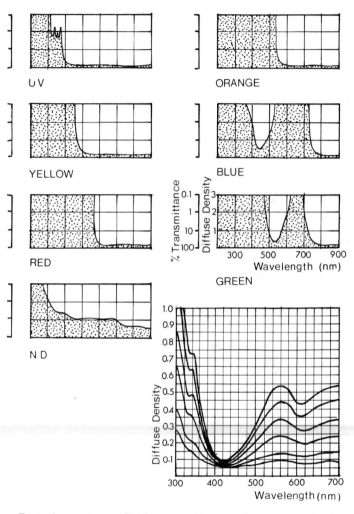

Transmittance curves. Plotting transmittance against wavelength of light gives a pictorial representation of filter colours. Diffuse density is the reciprocal of transmittance. It is used with pale filters, such as the blue colour compensating filter set shown here.

Representing colours

One problem of relevance to colour in general, and filters in particular, is the representation of different hues. Transmittance or reflectance curves show pictorially the distribution of wavelengths.

Colour circles, such as the one pictured on page 21 are useful ways of looking at colours, but are not easily transformed into unambiguous data. Additionally, the pure colours can be arranged in a number of other triangles, stars, squares and so on, but probably the circle is the easiest to understand. It is, however, once you start to add tones as well as hues (i.e. to take account of dilution or degradation) that colour diagrams become very complicated.

Natural colours can be thought of in terms of *hue, brightness* and *saturation.* Differences in hue are what we call colours: red, green, orange etc. Brightness relates to the amount of white (evenly distributed spectral energy) in the colour. Thus, brilliant colours are said to be brighter than pastel ones. Pink is pale red and so on. Saturation indicates how vivid, or how dull a colour is. Its converse, degradation, can be thought of as 'adding black' which is simply another way of saying 'absorbing some of the light'. If a substance reflects most of the red and some green light, it looks orange to us. If it reflects only a little of both these colours, but they remain in the same proportions, it looks brown. Orange is thus more saturated than brown, but has the same hue.

On the other hand, if some white light is added to the red and green mixture, the orange is then paler — so its brightness is lowered.

Colour systems, such as the Munsell system and the Ostwald system, use a set of standards against which an unknown sample is compared. Thus, any colour can be accurately defined by the numbers of the reference standard.

The Munsel system is one of the most comprehensive. It describes each colour in terms of its hue, value (brightness), and chroma (saturation). All colours can be placed within a three-dimensional solid. The solid may be portrayed as a 'colour tree' in which a series of vanes are arranged round a vertical axis. Each vane represents a slightly different hue, and complementary hues are opposite one another — just like a colour circle. On each vane, all the possible values and chroma for that hue are represented. For practical purposes, they are composed of small painted squares.

In its most commonly used form, the Munsell colour atlas uses a separate page for each hue. That is for every detectably different

colour found in a perfectly-formed colour circle. Each page is given a code — e.g. 3R is a particular red hue. The value and chroma are also numbered. So 3R 3/10 is moderately dark (3), and has a reasonably saturated chroma 10 steps away from neutral grey. This system allows extemely accurate colour matching, but is not especially informative about colour composition.

Colour temperature is used to define comparatively pastel colours. It is especially suited to evaluating the colour of light sources used in photography.

Tristimulus specification of a colour represents it numerically by the proportions of the three primary colours needed to produce it. The primaries may be defined exactly in terms of a spectral analysis, so this type of colour representation can be very accurate. The CIE system is the tristimulus specification most widely used, and is ideally suited to defining the colour of filters.

Colour temperature

The colour of any particular light-source can be described as the temperature to which a theoretically perfect radiator (called a black body) must be heated to emit light of that colour. The temperature is measured on the absolute scale and expressed in kelvins (K). To give the temperature in kelvins, 273.15 is added to the temperature in degrees celsius (°C).

The hotter a body gets, the bluer its radiation. Thus a light-source at a low colour temperature (say 2500 K) tends towards amber; and at a high colour temperature (say 6500 K) is bluish. Colour temperature describes only the visual appearance of the light. If the colour is produced by an irregular or discontinuous mixture of wave-lengths, it may have a quite different effect on photographic film. For example, on colour film, sodium vapour lamps come out red, and mercury vapour lamps green, although they appear yellow and almost purple to our eyes. Also, colour temperature takes no account of radiation outside the visible spectrum. Thus, basing the choice of materials or filters on the colour temperature of strong UV or IR emitters may have unexpected photographic results.

Despite this, for most practical purposes, the colour temperature of a light source is a good guide to the filters needed to give a neutral colour balance on transparency films. It is almost invariably satisfactory for exposing colour negative films — because fine adjustments of colour can be made at the printing stage.

CIE system

The CIE colorimetric system was devised in 1931 by the International Commission of Illumination (Commission International de l'Eclairage). It uses three imaginary primary colours. This allows all colours to be plotted as points on a plane surface. Constructing a system from the natural primaries would require a three-dimensional shape.

The choice of three primaries to lie on one plane produced a strange curve with the spectral wavelengths distributed round the edge. These are often only from 400 to 700 nm, but the system can be extended somewhat at either end as required. The specification recommends 300 to 830 nm for light sources. The three values, X, Y and Z, are always positive, and any colour can be described solely in terms of these figures. In fact, because the shape can be drawn on a plane surface, every point can be specified by two co-ordinates. These were called x and y in the original 1931 specification. In 1960, a new shape was calculated with different imaginary primaries, U, V and W. These give chromaticity co-ordinates, u and v. The two systems are mathematically interconvertible, and both are still in use.

As any colour can be represented on the diagram, the light transmitted by a filter can be given CIE co-ordinates. The co-ordinates, however, apply only to the filter illuminated by a particular light source. If the light source is altered, so is the colour of light transmitted by the filter, and thus the CIE co-ordinates.

Standard colours of light

As well as originating a system of colour representation, the CIE also specifed a number of standard types of illumination. *Sources* are physical light emitters, such as the sun, or a light bulb; and *illuminants* are simply light with a specified spectral distribution. In practice, the terms source and illuminant are often used interchangeably. CIE-specifed illumination types are defined as follows:

Source A – a gas-filled tungsten lamp with colour temperature 2854 K, i.e. an approximation to normal domestic tungsten lighting.

Source B – a similar lamp filtered (with a special liquid filter) to give a colour temperature of 4870 K; intended to approximate average noon sunlight (in temperate latitudes).

Source C – a similar lamp filtered (again with a special liquid filter) to

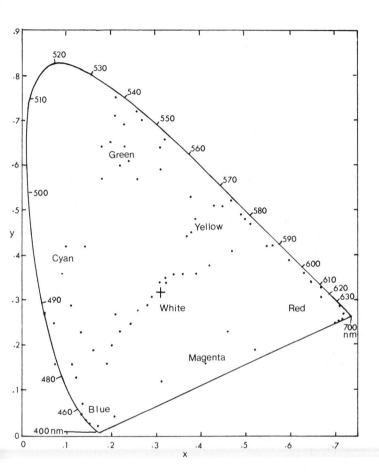

The CIE surface. Choosing suitable imaginary primary colours allows all colours to be represented on a plane. The strong hues are spread out round the edges; paler tints towards the centre. The exact positions of each filter depend on the colour of light shining through it. Thus, there are different CIE plots for different light sources.

give a colour temperature of 6770 K; intended to approximate daylight. (In fact it has rather less green than natural daylight.)

Illuminants D are calculated reconstructions of the measured composition of different types of daylight. There are a whole series of illuminants from 4000 to 25 000 K. The colour temperature is indicated by a subscript; thus D_{65} (or D_{6500}) is equivalent to daylight with a colour temperature of 6500 K.

CIE co-ordinates

The co-ordinates given to a filter (in a particular light source) define its colour. They do not directly define the spectral distribution of the light it transmits. Thus, identical CIE co-ordinates indicate that two filters look identical. They may, however, have a slightly different effect on a colour film. Their transmittance curves give a greater indication of their actual performance.

The names of filters

The colour of a filter is not its only variable. You may also want to know other specific properties. These can normally be seen from the transmittance curve, but are also given names. The commonly used spectral transmittance classifications include:

Sharp-cut or *narrow-cut* filters are those with an abrupt transition from transmission to absorption.

Short-wave pass filters transmit short waves and absorb longer waves – thus they include violet, blue and blue-green filters.

Long-wave pass filters conversely transmit only longer wave radiation. Thus, they include pale yellow, orange and red filters.

Bandpass filters pass only a narrow band of radiation. Most blue-green, green and deep yellow filters are of this type. Paradoxically, this definition is widened to include filters which transmit *all but* a fairly narrow band (which they absorb or reflect). Such filters include magentas and purples.

Monochromatic filters pass only an extremely narrow band of light. They are used to isolate light of a single wavelength from discontinuous light sources. Often two or more colours are combined to produce the most discriminating monochromatic combination.

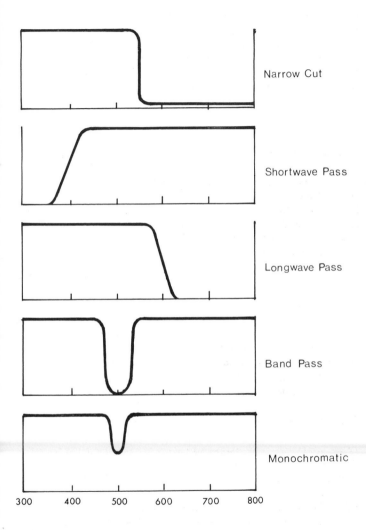

Narrow Cut

Shortwave Pass

Longwave Pass

Band Pass

Monochromatic

300 400 500 600 700 800

Filter characteristics are reflected in their transmittance curves. They have more or less the shapes shown here. Different colours can have the same curve shapes, but in different places along the wavelength axis.

In conclusion

The information in this chapter should help you to understand and use the information in filter catalogues. Naturally, you need much more knowledge for a scientific study of the subject; and even for photography, you may not always be able to predict your results exactly.

If you are in doubt about the effect of a particular filter, you must make some test exposures. Choose a subject with suitable colours and tones. Note *all* the relevant factors (films, filter, exposure, light source, meter reading etc.). Make sure that the film is processed and printed normally. Then you can see what the filters can do for you; and go on to use them in your creative photography.

Index